Art Chronicles
1954-1966

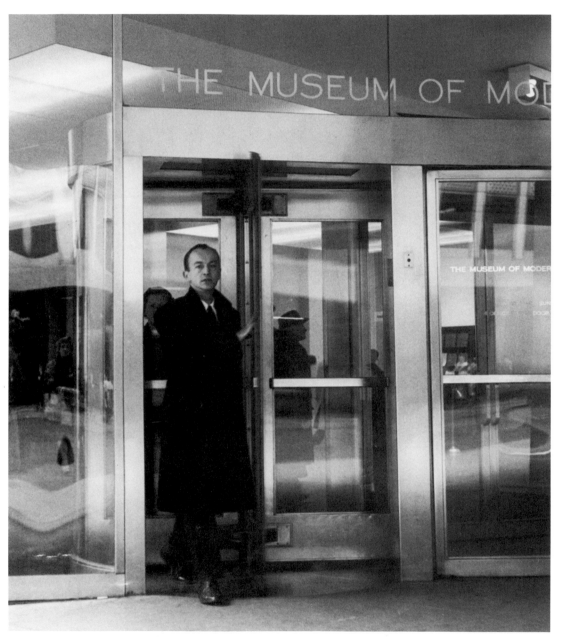

Frank O'Hara, Associate Curator of Painting and Sculpture at
The Museum of Modern Art. Photo, Fred McDarrah.

FRANK O'HARA

Art Chronicles
1954-1966

A V E N T U R E B O O K

George Braziller | New York

The Publisher wishes to thank:

Art and Literature for permission to reproduce
"Alex Katz" (Number 9, Summer 1966);
Art News for "Cavallon Paints a Picture" (December 1958),
"Growth and Guston" (May 1962),
"Introducing the Sculpture of George Spaventa" (April 1964);
Grove Press for "How to Proceed in the Arts,"
which appeared in *Evergreen Review* V, 19 (August 1961),
"Franz Kline Talking," from *Evergreen Review Reader 1957–1967* © 1968;
Horizon for "Why I Paint As I Do" (September 1959);
It Is for "5 Participants in a Hearsay Panel" (Number 3, Winter-Spring 1959);
Kulcher for "Art Chronicle" (Summer 1962);
The Museum of Modern Art for the introduction to *Motherwell* © 1962,
the introduction to *Nakian* © 1964,
the introduction to *Franz Kline, A Retrospective Exhibition* © 1960,
the introduction to *David Smith* © 1966.

For information address the publisher:
George Braziller, Inc., One Park Avenue, New York, N.Y. 10016

Library of Congress Catalog Number: 74–77526

International Standard Book Number: 0-8076-0755-X, cloth
0-8076-0756-8, paper

Printed in the U.S.A.

Designed by The Etheredges

Contents

Acknowledgments

We are particularly grateful to Donald M. Allen, literary executor, for his invaluable and constant attention and care in compiling the text for this selection, the chronology, and the bibliography. Our special thanks to Kynaston McShine for his information and assistance with this project. We appreciate the encouragement, suggestions, and time that Robert Motherwell has given. We are very appreciative of Waldo Rasmussen for his cooperation, information, and careful documentation of the chronology and bibliography. Our special thanks to Joseph Le Sueur for his assistance in providing several of the photographs of Frank O'Hara and of the artists.

WHY I AM NOT A PAINTER

I am not a painter, I am a poet.
Why? I think I would rather be
a painter, but I am not. Well,

for instance, Mike Goldberg
is starting a painting. I drop in.
"Sit down and have a drink" he
says. I drink; we drink. I look
up. "You have SARDINES in it."
"Yes, it needed something there."
"Oh." I go and the days go by
and I drop in again. The painting
is going on, and I go, and the days
go by. I drop in. The painting is
finished. "Where's SARDINES?"
All that's left is just
letters, "It was too much," Mike says.

But me? One day I am thinking of
a color: orange. I write a line
about orange. Pretty soon it is a
whole page of words, not lines.
Then another page. There should be
so much more, not of orange, of
words, of how terrible orange is
and life. Days go by. It is even in
prose, I am a real poet. My poem
is finished and I haven't mentioned
orange yet. It's twelve poems, I call
it ORANGES. And one day in a gallery
I see Mike's painting, called SARDINES.

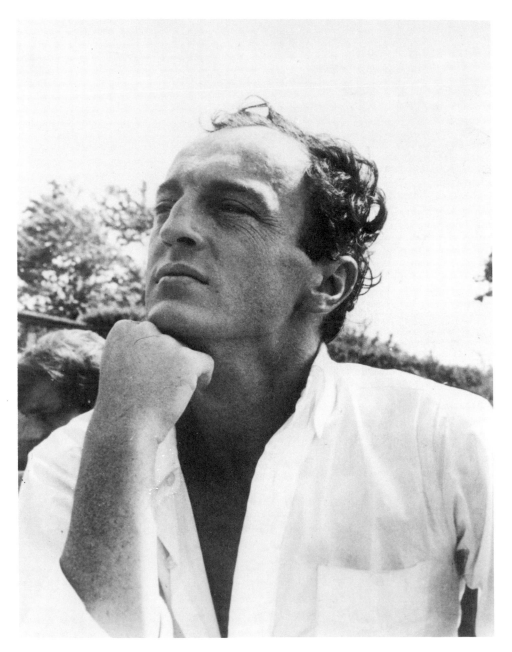

Frank O'Hara. Photo, Kenward Elmslie.

Art Chronicle

The other day I was at the Guggenheim Museum to see the ABSTRACT EXPRESSIONISTS AND IMAGISTS show again, but before going into the show itself it may be worthwhile, or at least different, to say something nice about the building itself. From long before construction work started on it, it had been a controversial thing, and it stayed so throughout the work on it, its opening, and its first several shows—every detail of its design was discussed everywhere from the newspaper to The Club, and rumors that its then-director might quit because he hated the floor, or the wall, or the dome, or the lighting, or even the elevator, were circulated. (He did leave subsequently, but apparently not because of F.L.W.) The museum is, of course, worthy of all this attention, and it has many merits not shared by other institutions of a similar or identical nature (and a few disadvantages: I don't like bumping into those pillars when I'm talking to somebody): it's wonderful looking from the outside, and when you enter the flat exhibition space on the ground floor the effect of the works near at hand, the ramps and over them glimpses of canvases, and then the dome, is urbane and charming, like the home of a cultivated

and mildly eccentric person. The elevator is a good idea too; I wonder if anyone has ever taken it down? And apart from the one-way thing about it, it takes off the curse of most elevators, which is that when you go up in an elevator in the daytime you are usually going to some unpleasant experience like work or a job interview, but here you are going up for pleasure. When you get to the top, and before beginning the descent (an opposite experience from that of Dante, since most often the important works are hung down in the "straight" gallery just above the main level), you used to get a miniature retrospective of Kandinsky from the museum's own collection, and right now there is a rather mute and interesting small show of newspapers, letters (as in H and F), and books by Chryssa. The downward stroll, then, is enhanced by the glimpses you've been sneaking (from the top this time) at the pictures on the lower ramps, and you get lots of surprises: things that looked especially inviting or dramatic from a partial look turn out to be totally uninteresting and others you hadn't bothered to anticipate are terrific (though this operation isn't invariable). Finally about this ramp, it almost completely eliminates the famous gallery-going fatigue. Your back doesn't ache, your feet don't hurt, and the light on the paintings, the variety of distance chosen for them to be against or away from the wall and towards you, is usually quite judicious—people who find it so hard to "see" the picture in the lighting of the Guggenheim should try going to the average studio in which most New York artists work before they complain. (I know museums aren't supposed to be studios, I'm talking about looking at really good paintings or sculptures, which frequently has little to do with locale or condition.) Anyhow, I like the whole experience, the "bins" where you come around a semi-wall and find a masterpiece has had its back to you, the relation between seeing a painting or a sequence of them from across the ramp and then having a decent interval of time and distraction intervene before the close scutiny: in general my idea is that this may not be (as what is) the ideal museum, but in this instance Frank Lloyd Wright was right in the lovable way that Sophie Tucker was to get her gold tea set, which she described as, "It's way out on the nut for service, but it was my dream!"

New York gallery-goers are used to feeling that no matter what they are looking at, the institution in question will dish it up to them with the appropriate importance so far as installation goes, hence the accusation that the Guggenheim makes certain paintings look inferior to their intrinsic quality. This is of course a fallacy: position in installation and lighting has nothing to do with esthetic importance. Actually, the only truly important new works to be shown in New York last and this

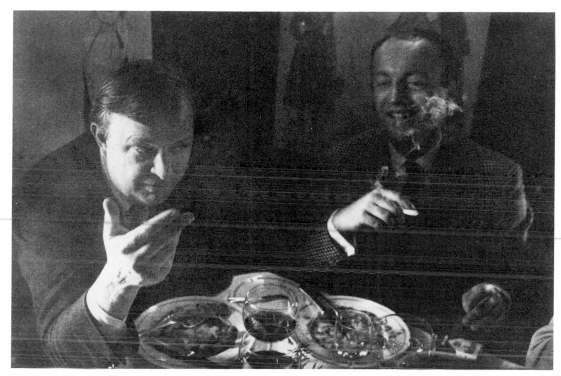

Robert Motherwell and Frank O'Hara at *La Cremaillère*,
Banksville, New York, March 1965.
Photo, Alexander Liberman.

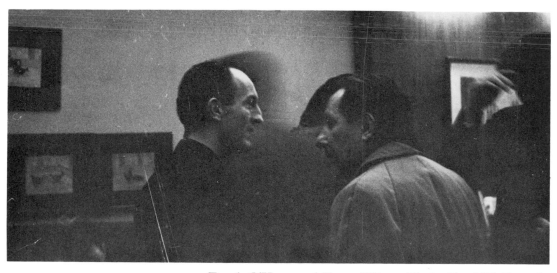

Frank O'Hara and Franz Kline. Photo, Fred McDarrah.

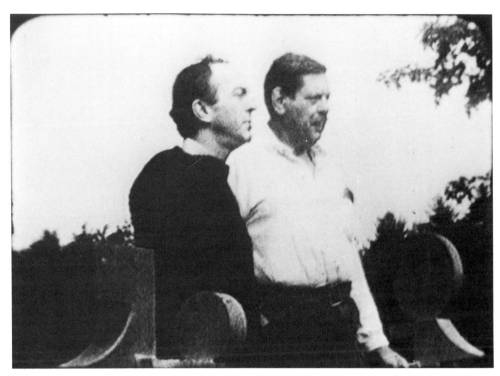

Frank O'Hara and David Smith at
Bolton Landing, New York.

season were the Matisse cut-outs at The Museum of Modern Art, and they could have been hung outdoors in the garden without jeopardizing this importance in the slightest (so long as it didn't rain). I am not saying that the abstract show at the Guggenheim shouldn't have been hung differently, since certain pictures did kill their neighbors and vice versa, but it had nothing to do with positioning for strategic importance. But the Bonnard in the Guggenheim's first show after its opening did not suffer from the light and the position, as often remarked, it is simply a property of Bonnard's mature work, and one of its most fragile charms; to look slightly washed-out, to look what every sophisticated person let alone artist wants to look: a little "down," a little effortless and helpless. He was never a powerful painter, per se.

At the opening of the abstract show at the Guggenheim several people were going around saying, "At last it looks like a real museum here," which is a terribly funny notion when you think that the Abstract Expressionist movement is basically antimuseum in spirit, and its mem-

bers were the only organized group to send out a letter of protest about the museum to the newspapers even before construction on the building had begun. The thing is that with this show the Guggenheim became part of New York, in that it featured New York's favorite art movement. And no matter how much Wright himself may have hated painting and sculpture, the physical set-up of the building does nothing to hurt that movement.

The selection is another matter: what the title implies is a summary of achievement, but what you get is recent works by most of the important members of the movement. This is very interesting, if you want to look at paintings. Unfortunately many people wanted to see a justification, packaged in a new Sherry's container, with a card saying, "Because of this show you are entitled to keep on admiring Abstract Expressionism." Hence the criticism the Guggenheim has gotten about the quality of the show, some of it near hysteria: "A WEAK HOFMANN! HOW COULD THEY!" None of the reviewers seems to have thought, "How could he!"

What does happen in the show, without disturbing anybody's reputation, is a shift in the emphasis of who is doing the interesting work: some artists maintain their vitality, others look terribly dull, younger members zoom to the fore, all on the fore-admitted basis of one recent work, so no images are toppled permanently. This is a perfectly fair thing to have happen and gives the show an air of free-wheeling accuracy. This is all living art and the show reflects the living situation: just as Al Held and Joan Mitchell and Philip Guston will absorb the imagination of one season, so do Michael Goldberg and Robert Motherwell and Franz Kline another. It depends on what you see and when it's shown and it keeps you fresh for looking and for the excitement of art. A lot of people would like to see art dead and sure, but you don't see them up at The Cloisters reading Latin.

The present show also, precisely because it is mainly made up of recent works, reflects another very human situation; the relation between artists of a given tendency is frequently very close. Why this should be a matter of concern to anyone but the artists themselves is beyond me, since the alternatives to this fortuitous happening are blindness or hypocrisy. Nevertheless, the viewer should make more distinctions than the artist, he has time and room for it, he is merely looking and experiencing, where the artist is creating something, whether in his own or another's image, no small feat in either case.

In a capitalist country fun is everything. Fun is the only justification for the acquisitive impulse, if one is to be honest. (The Romans were honest, they thought it was all girls, grapes and snow.) The Gug-

genheim Museum is fun, and as such it justifies itself. Abstract Expressionism is not, and its justifications must be found elsewhere. Not to say it as justification, but simply as fact, Abstract Expressionism is the art of serious men. They are serious because they are *not* isolated. So out of this populated cavern of self come brilliant, uncomfortable works, works that don't reflect you or your life, though you can know them. Art is not *your* life, it is someone's else's. Something very difficult for the acquisitive spirit to understand, and for that matter the spirit of joinership that animates communism. But it's there.

So what's good in this show and how does it look? Well it *looks* very good, as a matter of fact it looks better than it is. Not wanting to do a hugger-mugger in the Louvre, the dross always is self-effacing and disappears. So you are left with some terrific stuff:

one of the most interesting Brooks's in years, where the artist's exceptional skill at handling paint masses is roughened up somewhat and gets to a kind of Baroque literalness, joining Clyfford Still in his firmness about stopping-points;

a magnificent Motherwell, the kind of painting that everyone must dream of doing if they want to do anything at all: it has everything, it shimmers with a half-concealed light, it draws when it wants to, and withal it has an opulence and a majesty which is completely uncharacteristic of the American sensibility unless you think your mother went to bed with an Indian;

earlier I hinted at Al Held's show at the Poindexter Gallery last season, and his picture is terrific here—he is a wonderful artist, at the same time sensitive and blunt, related, and how gratifyingly, to the Gorky of the late thirties, and he is a clearer of the eye and mind; Held reminds you that color, form, shape (and there is a difference between form and shape), and nuance are still not giving the game over to the enemy—you don't have to become a clock any more if you're near a Held, he is not painting about position in time;

the Raymond Parker looked very beautiful and I for one hope that I never see another Parker with a thick gold band around it. It crowds the space too much, it falsifies the delicate balance and subtle correspondence of his near tones, and it is to the credit of the Guggenheim that it took it the way it was, though why the same manner wasn't adopted for his one-man show there earlier this year I can't imagine, even if it did manage to be impressive despite this handicap;

in relation to the other examples, I think the wrong Frankenthaler was chosen, expert as it is, for the context of the show, but more about her later. The Rauschenberg ditto, because if you think he should be in the

Larry Rivers and
Frank O'Hara.
Photo,
Renée Sabatello Neu.

show at all, it is as an Imagist rather than an Expressionist (both should be preceded by an Abstract, natch), and he should have been represented in force rather than in retirement, as is true in another way of the hangings of the Joan Mitchell and the Alfred Leslie, who are too sure of hand and distinguished of spirit to suffer this treatment without a sullen smile—one must simply see them elsewhere, yet they make their presence felt or I wouldn't mention them;

de Kooning has shown several single pictures recently of such a beauty that one wonders, if he ever does get around to having a show of the new abstractions, whether the Sidney Janis Gallery won't just go into an apotheosis, and the one here is no exception—I wish I could give credence to the next remark by thinking of a single indifferent work by de Kooning but I can't so here goes anyway: he is the greatest painter after Picasso and Miro;

Reuben Nakian, Frank O'Hara, and Elaine de Kooning at
the opening of the Nakian exhibition,
The Museum of Modern Art, June 1966.
Photo, George Cserna.

but not to run on, the *hits* of the show are mostly on the "mezzanine"
floor, the flat gallery where the absolutely superb Pollock, Still, and
Newman establish an aristocracy for American art which is unequalled
anywhere, in the developments after World War II.

Where else is the big, brave art happening? Certainly not in Paris,
where artisanship has claimed and cured even the most demented inten-
tions to the point where seeing Helen Frankenthaler's recent show, or
a single fugitive Kline, or something from the Spanish School (Tapiés or
Canogar or Saura), is a sock in the eye along the rue de Seine. Of
the younger generation there is only Riopelle, a gigantic spirit, with
Soulages and Alechinsky trailing formalistically (and authentically) up
towards the stars.

A lot of interesting things are happening right here which make
Paris and Rome seem quite dull and insensitive by comparison. There
is, of course, the construction-of-esthetic-objects movement, which since

the exhibition at The Museum of Modern Art will probably be designated fairly clearly as assemblagists. This is a very courageous direction because it deliberately vies with the fondness one feels for a found object, challenging in intimacy as well as structure all the autobiographical associations that a found object embodies. In Claes Oldenburg's recent exhibition THE STORE (107 East 2nd Street—the best thing since L. L. BEAN), you find cakes your mother never baked, letters you never received, jackets you never stole when you broke into that apartment, and a bride that did not pose for Rembrandt's famous Jewish ceremony. Somehow Oldenburg is the opposite of Britain's "kitchen sink" school: he can make a stove (with roast) or a lunch-counter display case lyrical, not to say magical. And he actually does do what is most often claimed wrongly in catalog blurbs: transform his materials into something magical and strange. If Red Grooms is the poet of this tendency and Jim Dine is the realist, then Oldenburg is the magician. His enormous cardboard figure at the Green Gallery, with its great legs stretched toward one on the floor, was sheer necromancy. Compared to these three artists, and adding to them Lucas Samaras and George Brecht, the European artists exploring this field are very dull. And the direction in itself must be taken quite apart from the work of Jasper Johns or Jean Follette or Robert Rauschenberg, each of whom has a separate and individual tradition behind their work, no matter what their influence may have joined together.

Rauschenberg had recently a very beautiful show at the Castelli Gallery and one unprecedented to my knowledge. It began as a group show, and gradually more Rauschenbergs moved in, while other works moved amiably out, as if to say, "Okay, Bob, this tune seems right for you, so take it, maestro, from Bar R." It was a beautiful show, and an event more interesting than many of the "happenings" downtown. The gallery kept changing the paintings, which gave an unusual urgency to gallery-going. If I hadn't been very lucky, I would have missed seeing *Blue Eagle,* a modern work which nobody should be deprived of. One should add that his (our) experience of the *Dante Illustrations* which Rauschenberg exhibited last year has left none of us less the richer for any occasion in the future. Doré had never the pertinence for his society that those works have for ours, nor the beauty, nor the perception. So we all have that, too.

In the opposite camp, the "tradition of the new" traditional Abstract Expressionist movement, lie Norman Bluhm's paintings, although jet or explode may be a more accurate word. A great deal has been written about the influence of Pollock, but that is all about the *look,* the technique

The opening of the Robert Motherwell exhibition,
The Museum of Modern Art, New York,
October, 1965.

which is best known (Pollock had several). Bluhm is the only artist
working in the idiom of Abstract Expressionism who has a spirit similar
to that of Pollock, which is to say that he is *out*—beyond beauty, beyond
composition, beyond the old-fashioned kind of pictorial ambition. And
Jasper Johns is somehow in this area, a very misunderstood artist, whose
art presents to many something easily assimilable and understood, but
Johns is one of the most mysterious artists of our time, an artist whose
work is *not* formal, in the sense that it is understood and expounded. He
has the experience, which may or may not be unfortunate for him, of
seeing his paintings greeted with delight because the images are recogniz-
able when they are filled with pain. At least that is one way of feeling

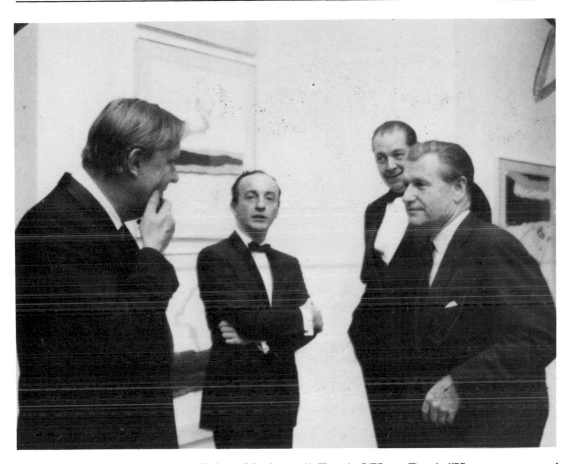

Robert Motherwell, Frank O'Hara, René d'Harnencourt, and Nelson Rockefeller at the opening of the Motherwell exhibition. Photo, Allen Baum.

them: one may say that the meticulously and sensually painted rituals of imagery express a profound boredom, in the Baudelairean sense, with the symbols of an over-symbolic society, as Oedipus unconsciously exposed the errors of a familial sentimentality based on disgust.

Bluhm's art, on the other hand, and they are arbitrarily juxtaposed, has the other Grecian impulse which inspired fountains, temples, and conquest. Johns's business is to resist desire, Bluhm unconsciously inspires it. But more, of course, must be thought about both.

Jackson Pollock

Art is full of things that everyone knows about, of generally acknowledged truths. Although everyone is free to use them, the generally accepted principles have to wait a long time before they find an application. A generally acknowledged truth must wait for a rare piece of luck, a piece of luck that smiles upon it only once in a hundred years, before it can find application. Such a piece of luck was Scriabin. Just as Dostoievsky is not only a novelist and just as Blok is not only a poet, so Scriabin is not only a composer, but an occasion for perpetual congratulations, a personified festival and triumph of Russian culture.

PASTERNAK, I REMEMBER
(Essai d'Autobiographie)

And so is Jackson Pollock such an occasion for American culture. Like the Russian artists Pasternak mentions, his work was nourished by international roots, but it was created in a nation and in a society which knew, but refused to acknowledge, the truths of which Pasternak speaks.

We note that Pasternak puts these general truths in the plural, for culture is capable of entertaining more than one truth simultaneously in a given era. Few artists, however, are capable of sustaining more than one in the span of their activity, and if they are capable they often are

12

met with the accusation of "no coherent, unifying style," rather than a celebration. Even Picasso has not escaped from this kind of criticism. Such criticism is panoramic and nonspecific. It tends to sum up, not divulge. This is a very useful method if the truth is one, but where there is a multiplicity of truths it is delimiting and misleading, most often involving a preference for one truth above another, and thus contributing to the avoidance of cultural acknowledgment.

If there is unity in the total oeuvre of Pollock, it is formed by a drastic self-knowledge which permeates each of his periods and underlies each change of interest, each search. In considering his work as a whole one finds the ego totally absorbed in the work. By being "in" the specific painting, as he himself put it, he gave himself over to cultural necessities which, in turn, freed him from the external encumbrances which surround art as an occasion of extreme cultural concern, encumbrances external to the act of applying a specific truth to the specific cultural event for which it has been waiting in order to be fully revealed. This is not automatism or self-expression, but insight. Insight, if it is occasional, functions critically; if it is causal, insight functions creatively. It is the latter which is characteristic of Pollock, who was its agent, and whose work is its evidence. This creative insight is the greatest gift an artist can have, and the greatest burden a man can sustain.

The early works

Although Pollock is known as the extreme advocate of nonfigurative painting through the enormous publicity which grew up around his "drip" paintings of the late 1940s and early 1950s, the crisis of figurative as opposed to nonfigurative art pursued him throughout his life. Unlike his European contemporaries, art for him was not a matter of deciding upon a style and then exploring its possibilities. He explored the possibilities for discovery in himself as an artist, and in doing so he embraced, absorbed, and expanded all the materials which he instinctively reached for, and which we later find to be completely pertinent to the work. His method was inclusive: he did not exclude, from one period to another, elements in which he had found a previous meaning of a different nature. Thus it is that we find a relationship, however disparate in meaning, between the forms of the early *Untitled,* c. 1936 and the *Moon Vibrations* of 1953, between the *Untitled,* 1937 (Fig. 1), which Sidney Janis has pointed to as perhaps the first of the radically "all-over" paintings later to be the preoccupation of a number of his contemporaries, and his own later "all-over" paintings, such as the *Untitled* of 1950 (Fig. 2) and the *Frieze* of 1953–55. So the figurative images of the great black-and-white period

13

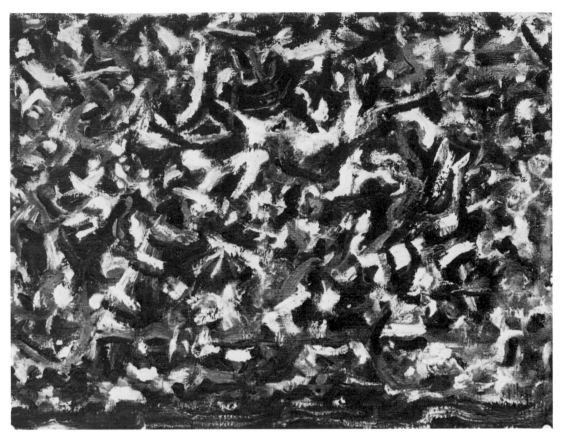

1. *Untitled,* 1937. Oil on canvas, 15″ × 20″.
Collection, Lee Krasner Pollock, New York. Photo, Oliver Baker.

of 1951–52 relate to the numerous early drawings in which he changed the idioms of Picasso and André Masson into his own (naturalistic then) conception of space and incident. A good example of what he accomplished in the latter case, where space becomes the field of incident, may be seen in the *White Horizontal,* 1941–47 (Fig. 3), an accomplishment which Pollock did not dwell on, though the ramifications of what he found in doing it linger in his work and the work of others to this day.

The Mexicans

Pollock, from the first, had quite apparently a flair for drama, in the sense of revelation through stress and conflict. His student period has been so well and thoroughly expounded by Sam Hunter in the preface of the

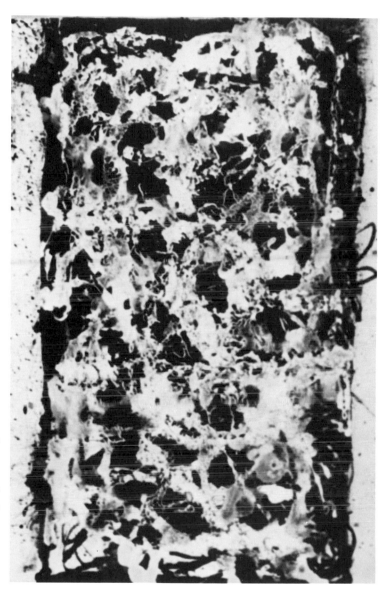

2. *Untitled*, 1950.
Oil on canvas,
21½" × 11¾".
Collection,
Lee Krasner Pollock,
New York.
Photo, Oliver Baker.

Pollock exhibition he organized for The Museum of Modern Art in 1956, that a detailed retracing of his development would be repetitive.

It is not surprising that Pollock, after experiencing the attempt made by his teacher Thomas Benton toward heroic regional expression, should have become interested in the works of Rivera, Orozco, and Siqueiros, which were then very much in the air. By the middle thirties, Rivera had already painted murals in New York, San Francisco, and Detroit, as well

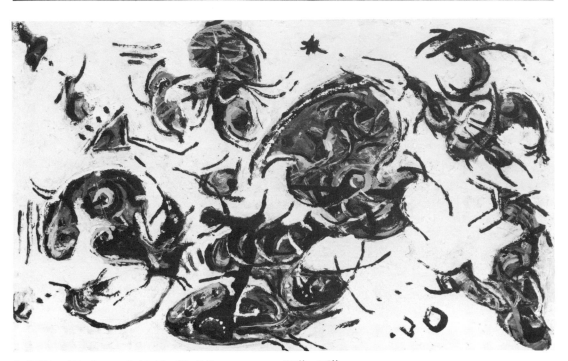

3. *White Horizontal,* 1941–47. Oil on canvas, 22″ × 36″.
Private collection. Photo, Oliver Baker.

as the one for Rockefeller Center which was refused in the face of great publicity because of the portrait of Lenin. By this time Rivera had also delivered his famous dictum that art should express "the new order of things . . . and that the logical place for this art, . . . belonging to the populace, was on the walls of public buildings." Though Pollock was undoubtedly more interested in the works of Orozco and Siqueiros, this statement of Rivera's may have somehow pointed the way to the heroic scale of his early *Mural* and the huge masterpieces of 1950, *Autumn Rhythm, Number 32,* and *One* (Fig. 4). These are indeed paintings for the populace, as well as for individual pondering.

The drawings and paintings done during the period of Pollock's interest in Orozco and Siqueiros, however, seem to me to be studies of their unabashedly dramatic treatment of subject—it is not art which interested him here, but their attitude toward content, their convictions. American "social-content" paintings of the 1930s and early 1940s seem very tentative by comparison. And Thomas Benton, in introducing El Greco and the Italian Mannerists into the Great Depression, did an unusually interesting thing, no matter how the actual paintings turned out, but it was not a powerful thing.

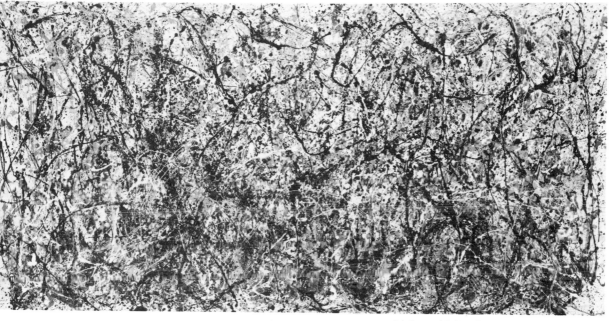

1. *One*, 1950. Oil on canvas, 9′ × 17′.
Collection, The Museum of Modern Art, New York.
Photo, The Museum of Modern Art, New York.

Surrealism

The influence of Surrealism, though as a movement it provoked few masterpieces, has been considerable and seldom has been given its just due. It is true that the Surrealist periods of Picasso, Miró, and others produced great works, but the powerful personalities of these artists, the broad sweep of their creativity, tends to minimize their debt to Surrealism. For American painters, I think, the importance of Surrealism's influence lay in a less direct stimulation. For instance the whole basis of art-consciousness and art-confidence in America was changed by Surrealism, and even if more literary than painterly works influenced American life, the basic findings of the Surrealist struggle toward subliminal meaning has not failed to affect all modern art which is not commercial, and much that is ("the hidden persuaders," for instance).

The basic theory of Surrealism is a far greater liberation from the restrictions of preconceived form than any amount of idiosyncratic experimentation, and it finally destroyed the post-Renaissance vision of visual structure supported by the rationalizations and syllogisms of semi-popular science. That the principles of Surrealism were often expounded in painting by means perversely counter to the genuine accomplishment of

Cubism does not negate the fact that Surrealism destroyed, where Cubism only undermined on the same rationalistic basis as before. Cubism was an innovation, Surrealism an evolution. The former dealt with technique, the latter with content. The truths implicit in Surrealism were touched upon and hinted at by Picasso (who did not need them) and Masson (who did), but they had to wait for the works of Pollock, and of such other American artists as Mark Rothko and Clyfford Still, to be acknowledged, to come to life, to speak, to apply. Surrealism enjoined the duty, along with the liberation, of saying what you mean and meaning what you say, above and beyond any fondness for saying or meaning. Max Ernst is to me a "fond" painter. As with those images of the American Indian, of sand-painting, that most natural and fragile of arts, those images of the Western reaches, all of which seem to have haunted his subconscious from time to time, recurring by allusion, the many "influences" which can be traced are less interesting as influences than as materials for Pollock's spirited revaluation. Now that Pollock has touched and clarified them, it is hard to see these materials as he found them. In their quality, which he created by his work and which we find by relating them to him, not by his analogy to them, he has given them reality for us outside his work, as a cultural by-product of his own achievement. This goes, too, for Miró, whose work has been enhanced for us by Pollock.

Arshile Gorky

Gorky, that magnificent painter, provides us with a case of artistic revaluation which contrasts with that of Pollock. For in Gorky pertinent developments of much European art, not only recent, were assimilated for American painting. But it was at the expense of Europe. Gorky, by his peculiar genius for something-of-value, is able to make a certain aspect of Picasso boorish, Miró frivolous, Masson leaden; and even a master like David may seem overexplicit when compared to *The Orators* (now destroyed) or *Diary of a Seducer*. Not so Pollock, who did not appropriate (as an artist has every right to do—I am simply making a distinction) what was beautiful, frenzied, ugly or candid in others, but enriched it and flung it back to their work, as if it were a reinterpretation for the benefit of all, a clarification and apotheosis which do not destroy the thing seen, whether of nature or art, but preserve it in a pure regard. Very few things, it seems, were assimilated or absorbed by Pollock. They were left intact, and given back. Paint is paint, shells and wire are shells and wire, glass is glass, canvas is canvas. You do not find, in his work, a typewriter becoming a stomach, a sponge becoming a brain.

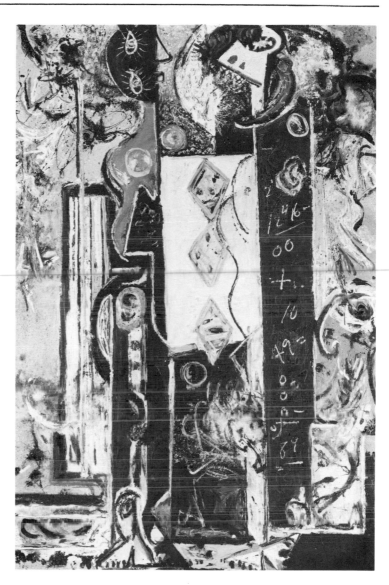

5. *Male and Female,* 1942.
Oil on canvas, 73¼" × 49".
Collection,
Mrs. H. Gates Lloyd.
Photo, Philadelphia
Museum of Art.

Male and Female, 1942

His first masterpiece, *Male and Female* (Fig. 5), was painted when
Pollock was thirty and sums up the interests of the preceding years, fluent
in imagery, strong in stance; the two protagonists face each other in a
welter of cabalistic signs and numbers and emotional flurries. They are in
search of a unifying symbol. This unity is found by Pollock through the
confusion of their aims and choices, in the unity of their search, which is
mutual. Like Picasso's famous *Girl before a Mirror,* the images reflect each

19

other's sexual characteristics, but now the emphasis is on the love which has occasioned their search. The sexual imagery is extraordinarily complex in that it seems to be the result of the superimposition of the protagonists at different stages of their relationship. They are not double-images in the routine Surrealist sense, but have a multiplicity of attitudes. At different times one sees them facing each other, then both facing in the same direction (to the left), then with their backs to each other but the memory of the confrontation vivid in their appearance. Suggestions of eyes (upper and middle right, left-of-center and lower left) peer at the viewer, as if to guard the lovers without veiling them. Their youth and ambivalence are carried by the brilliance of the color and its almost brutal relevance to the subject.

Since several of the paintings of this period have mythological titles, it may not be idle to wonder if perhaps this male and female do not have some allegorical significance. Certainly the painting is not "about" Surrealist or Freudian sexual motivations. It is an expression of classical, resolved violence; one is present at the problem and at the solution simultaneously. The imagery is not privately sensual, but categorically sexual, forensically expounded. The obscurity of the relationship is made utterly clear. The occasion is important and public.

In *The She-Wolf* (Fig. 6) of the following year, one of six works which bear on the probability of allegory, Lupa, the saving nurse of Romulus and Remus, is advancing with full dugs toward a child whose face appears in the lower left. This is undoubtedly Romulus, for though the wolf nursed both brothers, Romulus later killed Remus. She is not yet giving suck, and Romulus, the stronger, would be first to feed.

That Pollock was deeply interested in the mythology surrounding Romulus and Remus seems fairly certain. To cite only a few instances, we may remember that when Romulus and Remus came to vie for the rule of what was to be Rome, precedence was decided by omens and flights of birds. Remus saw only six vultures, Romulus twelve; therefore Romulus ruled. This may be the subject of *Bird Effort,* 1946. Later Romulus, after killing his brother, was shunned by his neighbors. By establishing a sacred grove as sanctuary, he surrounded himself with a number of criminals, fugitives, and foreigners (the future citizens of Rome). Deprived of the possibility of intermarriage with the neighboring inhabitants, Romulus established games and feasts in honor of the god Consus, held in great secrecy, to which were borne kidnapped virgins. It is these festivities, perhaps, that *Guardians of the Secret* (Fig. 7) is celebrating, a painting which is a marvel of spatial confinement and passionate formalism, formalism brought to the point of Expressionistic defensiveness. If so, the *Wounded Animal* is one of the sacrifices at these Consualia. We

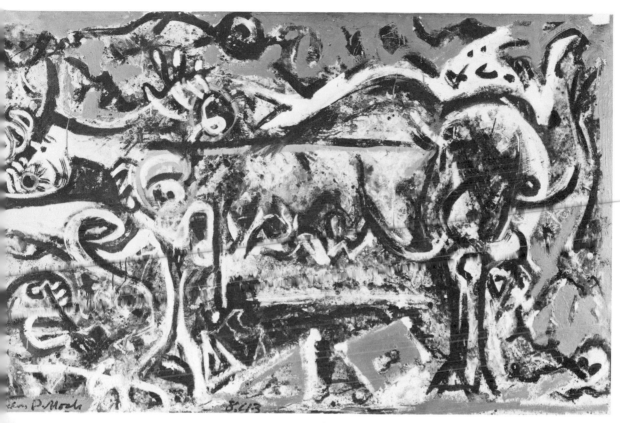

6. *The She-Wolf,* 1943. Oil on canvas, 41⅞" × 67".
Collection, The Museum of Modern Art, New York.

are told that during one of these celebrations the rape of the Sabine women took place. As we all know, the Sabines were defeated, but a major disaster was averted by the intervention of the Sabine women, who entreated their parents and husbands to lay down arms. All the Sabines then came to live in Rome, and their king ruled jointly with Romulus. It seems to me that the strange love and ambivalence of *Male and Female* reflects this embracing of the Romans and the Sabines, which we are told had such "salutary consequences." The *Mural* must be the bacchanalian festival attending this resolution, imbued as it is with the abstract ardor of the images in the other paintings of this group.

Pasiphaë and others

All this may be pushing interpretation to a rather fancy point, but if it is wrong it at least brings one to look closer at the works, either to

21

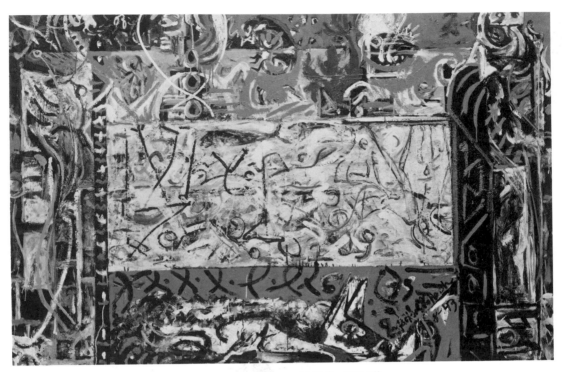

7. *Guardians of the Secret,* 1943. Oil on canvas, 48⅜″ × 75¼″.
San Francisco Museum of Art.

prove or disprove it. Nor are we finished with mythology quite yet. It is amazing how thoroughly Pollock investigated the derivations of Surrealism which were especially pertinent to his temperament without deviation into facility or mystification. The greatness of *Pasiphaë* (Fig. 8) lies in the candor of its richness and licentiousness. Its varied palette produces an aura of vigorous decadence, like the pearly, *cerné* eyelids of Catherine the Great, vigorous to the point of ennui. It is not just a glamorous painting, it is glamor in painting. Far from the sterile liberalism of a Gide, Pollock encompasses the amorous nature of bestiality (which most of the Surrealists were ambitious to do, but were either precocious or queasy about accepting) and gives it credit for originality of impulse and action. In this painting, mythological still, we move away from the area of allegory into the human disaster of desire—fatal, imaginative, willful. It is the ritual of an original human act, and therefore noble—where the mythology comes in, is that the artist sees it in all its legendary splendor, not as a tale told by a tart in a Melbourne bar (as T. S. Eliot or Francis Bacon might do). The stark, staring, and foreboding figure of Pasiphaë is present,

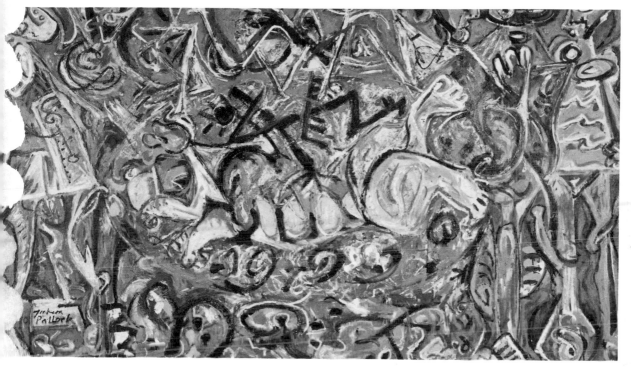

8. *Pasiphaë*, 1943. Oil on canvas, 56⅛″ × 96″.
Collection, Lee Krasner Pollock. Courtesy, The Marlborough Gallery, New York.

with her foreknowledge of the Minotaur and her lust, as are the other figures of her fancy or necessity; a rectangle at left containing the signature of the artist is like a calendar of her doom. This is a recognition of the ritual which he is renewing. For in Pollock it is not a god in the form of a bull who seduces Pasiphaë. It is the bull.

If *There Were Seven in Eight,* a remarkable work of 1945, is based as I believe on the *Seven Against Thebes,* it also bears a strong relationship to the *Mural* of 1953. The iconography is less discernible than in *Pasiphaë* (Fig. 8), which is almost its companion painting, yet it is still strongly involved in the ritualistic discovery of a recognizable event. Glowing and subdued, its double-figures are dominated by an equally double single-figure, that of Eteocles-Polynices, the brothers who agreed to share on alternate years the kingdom of their dead father, Oedipus. When they disagreed, Eteocles being unwilling to give up the throne in his turn to Polynices, they marshaled seven generals against each other. The battle at a stalemate, the "eighth" of each side agreed to decide the issue in personal combat, and the two brothers slew each other. If the cool ardor and con-

cern with linear power of this painting is related to this myth, the myth is also germane to an understanding of its complicated juxtapositions, and its mysterious unity of forms.

Added

Thanks to the special interpretation his temperament put upon Surrealism, Pollock, alone in our time, was able to express mythical meanings with the conviction and completion of the past. Whatever qualities he saw in these myths, they were not the stereotyped, useful-to-the-present ones, which have made so many playwrights into dons, so many painters into academicians.

Gothic, 1944 (Fig. 9)

Here is the efflux of the soul,
The efflux of the soul comes from within through
* embower'd gates, ever provoking questions,*
These yearnings why are they? these thoughts in the
* darkness why are they?*
—WHITMAN

Totemism

The use of totemic figures in varying degrees of abstractness occurs in several periods of Pollock's work. They are the household gods, so to speak, of his interest in American Indian art and they seem always to present a protective influence in the painting. We see this figure in the early *Birth* of 1937 in all its complicated life-renewal; in *Guardians of the Secret,* 1943 (Fig. 7), the two totemic guardians stand to right and left of the central rectangle which contains the hieroglyphic secret, while underneath crouches the Anubis-like dog with one eye open and ears alert. Or are these figures Romulus and Remus themselves, guarding their young city from its hostile neighbors with the help of the She-Wolf? All these interpretations may be pertinent, for *Guardians of the Secret* is a meeting of Near East and Far West, a painting of superb unity created from the fusion of elements of Egyptian, Roman, and American Indian art. That the meaning of these totemic figures is evocative rather than denotative, is true to the nature of totemic art.

After exploring these figures with great authority and finality in the two beautiful paintings of 1944 and 1945, *Totem I* and *Totem II,* Pollock in the following year seems to move directly into the "secret." It appears that the central rectangle of *Guardians of the Secret* had become the painting-subject not only of the two prophetic works of this year, *The*

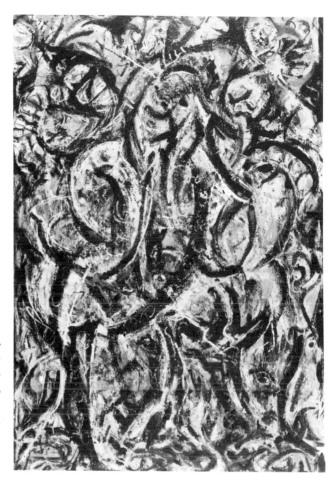

9. *Gothic*, 1944.
Oil on canvas, 84½″ × 56″.
Collection, Lee Krasner Pollock.
Courtesy,
The Marlborough Gallery,
New York.

Blue Unconscious and *The Key,* but also of much of the nonobjective work which followed and which solved the hieroglyphic secret and dissolved its signs in a lyricism of immediate impact and spiritual clarity.

Action Painting

In the state of spiritual clarity there are no secrets. The effort to achieve such a state is monumental and agonizing, and once achieved it is a harrowing state to maintain. In this state all becomes clear, and Pollock declared the meanings he had found with astonishing fluency, generosity, and expansiveness. This is not a mystical state, but the accumulation of decisions along the way and the eradication of conflicting beliefs toward the total engagement of the spirit in the expression of meaning. So difficult is the attainment that, when the state has finally been reached, it seems that a maximum of decisions has already been made in the process, that

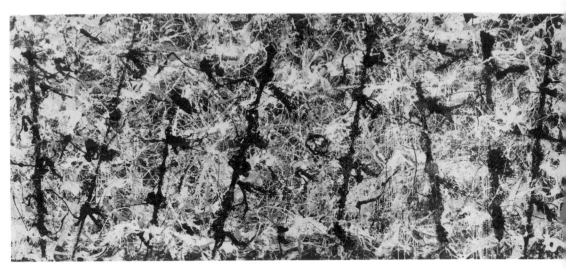

10. *Blue Poles,* 1953. Oil on canvas, 83″ × 129½″.
Australian National Gallery. Photo, courtesy Max Hutchinson.

the artist has reached a limitless space of air and light in which the spirit can act freely and with unpremeditated knowledge. His action is immediately art, not through will, not through esthetic posture, but through a singleness of purpose which is the result of all the rejected qualifications and found convictions forced upon him by his strange ascent.

But how much clarity can a human being bear? This state may be the ultimate goal of the artist, yet for the man it is most arduous. Only the artist who has reached this state should be indicated by Harold Rosenberg's well-known designation Action Painter, for only when he is in this state is the artist's "action" significant purely and simply of itself. Works of this nature are new in the history of Western civilization, and the spiritual state of their creation is as different from that of previous artists as is the look of the paintings different from that of previous paintings. Action Painting did not emerge miraculously from the void, and it is interesting and even comforting to make not-too-far-fetched analogies with the works of predecessors because art is, after all, the visual treasury of man's world, as well as of individual men. Nevertheless this new painting does have qualities of passion and lyrical desperation, unmasked and uninhibited, not found in other recorded eras; it is not surprising that faced with universal destruction, as we are told, our art should at last speak with unimpeded force and unveiled honesty to a future which well may be nonexistent, in a last effort of recognition which is the justification of being.

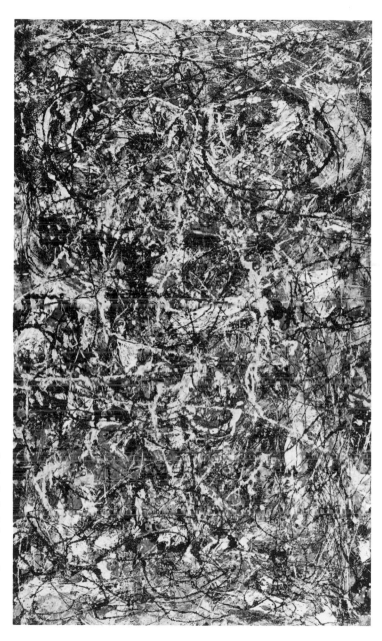

11. *Full Fathom Five*, 1947.
Oil on canvas with
nails, tacks, buttons, key,
coins, cigarettes, matches, etc.,
50 7/8" × 30 1/8".
Collection, The Museum of
Modern Art, New York;
gift of Peggy Guggenheim.

Pollock's works of this nature, which appeared from 1947 to 1950 and again in 1952–53, culminating in the heroic *Blue Poles* (Fig. 10), are painfully beautiful celebrations of what will disappear, or has disappeared already, from his world, of what may be destroyed at any moment. The urgency of his joy in the major works of this period is as great, and as

27

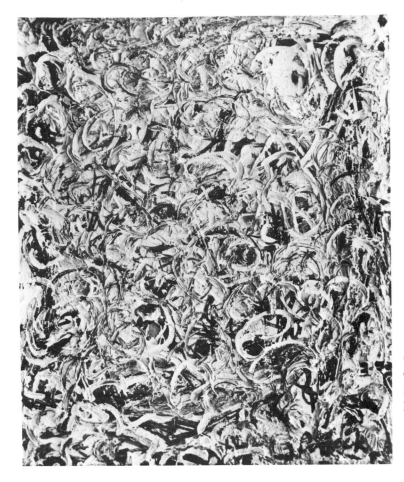

12. Shimmering Substance,
1946.
Oil on canvas, 30⅛″ × 24¼″.
Collection,
Museum of Modern Art,
New York.

pertinent to our time, as the urgency of *Guernica,* not with the latter masterpiece's obviousness.

1947 to 1950

Not that the nonobjective paintings of Pollock are devoted entirely to this joy. With means continually more inventive and radical, he pushed a wide range of expressive utterances to remarkably personal lengths. Despite his intense activity, the works never became categorical or doctrinaire. Each is an individual, a single experience. *Full Fathom Five* (Fig. 11) is full of nostalgia, its dominant color a green that is like a reminiscence of blue, with linear trailings of black, flowery-white and aluminum, with exclamations of orange, and a number of extraneous objects imbedded in the surface, like souvenirs of accident: a cigarette, half

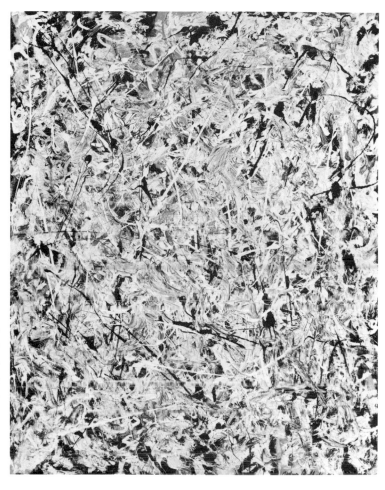

13. *White Light,* 1954.
Oil on canvas, 48½″ × 38″.
Collection,
Museum of Modern Art,
New York.
Photo, Oliver Baker

its paper torn off to expose the tobacco, two keys, nails, a cluster of tacks, and paint-tube tops making little blind eyes here and there. Earlier the "eyes" were painted to a more Expressionistic effect in *Eyes in the Heat,* and they also are hinted at in the heavy impasto of *Shimmering Substance* (Fig. 12). *Cathedral* is brilliant, clear, incisive, public—its brightness and its linear speed protect and signify, like the facade of a religious edifice, or, in another context, the mirror in the belly of an African fetish, the mysterious importance of its interior meaning (as anticipated in *Magic Mirror,* another "white" painting of 1941). *Eyes in the Heat II,* on the other hand, is a maelstrom of fiery silver; it is one of those works of Pollock, like *Shimmering Substance,* 1946, and the *White Light* (Fig. 13), which has a blazing, acrid, and dangerous glamor of a legendary kind, not unlike those volcanoes which are said to lure the native to the lip of the crater and, by the beauty of their writhings and the strength of their fumes,

cause him to fall in. These smaller paintings are the *femmes fatales* of his work.

*I am ill today but I am not
too ill. I am not ill at all.
It is a perfect day, warm
for winter, cold for fall.*

*A fine day for seeing. I see
ceramics, during lunch hour by
Miro and I see the sea by Léger;
Light, complicated Metzingers
and a rude awakening by Brauner,
a little table by Picasso, pink.*

*I am tired today but I am not
too tired. I am not tired at all.
There is the Pollock, white, harm
will not fall, his perfect hand*

*and the many short voyages. They'll
never fence the silver range.
Stars are out and there is sea
enough beneath the glistening earth
to bear me toward the future
which is not so dark. I see.*

This is the classical period of Pollock, classical in all its comprehensive, masterful, and pristine use of his own passions, classical in its cool, ultimate beauty, classical in that it is "characterized especially by attention to form with the general effect of regularity, simplicity, balance, proportion, and controlled emotion," to quote the dictionary. In the sense of this definition Pollock is the Ingres, and de Kooning the Delacroix, of Action Painting. Their greatness is equal, but antithetical. Because of this, to deny one would be to deny the other.

During this period Pollock made several friezes, including the *Number 24,* 1948, with its drenched pools of white in black let into an ocher ground punctuated with red; *Summertime,* a strange, serpentine flourish with colored-in areas bounded with black, as in a stained-glass window, and pointillist strokes here and there, denoting warm air; *White*

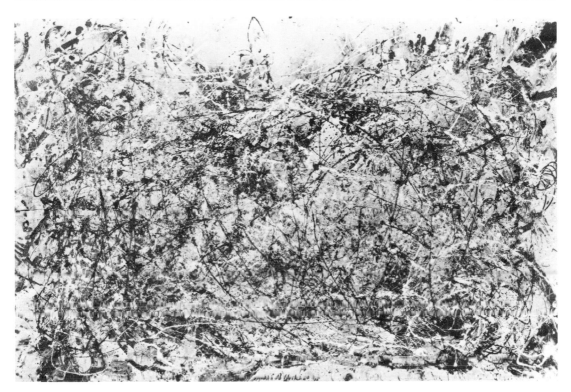

14. *Number 1*, 1948. Oil on canvas, 68″ × 104″.
Collection, The Museum of Modern Art, New York.

Cockatoo, a lavish iconography of color and charm, perhaps his most
amiable painting—and several others, each distinctive and original in
their exploration of format and possibility. In these works we see a
Pollock relaxed and grand, in the opposite mood from his earlier (and
later) Gothic aspiration, not building, but writing out his marvellous
inspirations in a full lyric hand.

The friezes seem soft and luxurious compared to the great paintings
of this period, several of them masterpieces of twentieth-century art. *Num-
ber 1,* 1948 (Fig. 14), has an ecstatic, irritable, demanding force, an in-
credible speed and nervous legibility in its draftsmanship; and the seem-
ingly bloodstained hands of the painter, proceeding across the top just
beyond the main area of drawing, are like a postscript to a terrible experi-
ence. *Number 5,* 1948, reveals the opposite kind of mastery, a structure of
vigor and fullness, which seems to present the respite of accomplishment.
In *Number 1,* 1949, one of the most perfect works of his life or anyone

31

else's, viewer or artist, Pollock gives us a world of draftsmanship, color, and tactile profundity which relates him to Watteau and Velasquez. It is a work of purity, modesty, and completion. At one time it was thought that the "all-over" paintings of Pollock represented an infinitely extensible field of force which could continue out into all four areas of space surrounding its boundaries. This is true of sight, but his work is not about sight. It is about what we see, about what we *can* see. In the works of this period we are not concerned with possibility, but actuality. *Number 1* could not but *have* exactly what it *has*. It is perfection.

There has never been enough said about Pollock's draftsmanship, that amazing ability to quicken a line by thinning it, to slow it by flooding, to elaborate that simplest of elements, the line—to change, to reinvigorate, to extend, to build up an embarrassment of riches in the mass by drawing alone. And each change in the individual line is what every draftsman has always dreamed of: color. The quick, instinctive rightness of line in a work like the *Drawing* of 1950 is present in profusion in the major works of this period, whether it takes on the cool Baroque quality of *Number 2,* 1949, or fuses in a passionate exhalation, as in *Lavender Mist.* That it could be heroic (*One,* 1950—Fig. 4), ritualistic (*Autumn Rhythm*), and dramatic (*Number 32,* 1950) is not so much a credit to technical flexibility as to purpose. It was Pollock's vision that was infinitely extensible. *Number 28,* 1950, belongs in this company, and *Convergence.* With *Number 12,* 1952, we are in a different area. Following the burgeoning sensitivity of *Convergence,* it is a big, brassy gigolo of a painting; for the first time the aluminum paint looks like money, and the color is that of the sunset in a technicolor Western. But its peculiar quality is its natural vulgarity: it is not beautiful, but it *is* real. And it may be arbitrary. Yet, the arbitrary was already conquered in *Out of the Web* which, despite its gouged-out forms, has the subtle luminosity of a pearl.

Perhaps the most remarkable work of 1950, from a technical standpoint, is the *Number 29* (Fig. 15). A painting-collage of oil, wire-mesh, pebbles, and shells composed on glass, it is majestic and does not depend on novelty for its effect. It is unique in that it is a masterpiece seen front or back, and even more extraordinary in that it is the same masterpiece from opposite sites of viewing. What an amazing identity *Number 29* must have!—like that of a human being. More than any other work of Pollock, it points to a new and as yet imponderable esthetic. It points to a world a young experimentalist like Allan Kaprow, who has written on Pollock in another vein, is searching for, and it is the world where the recent works of Robert Rauschenberg must find their emotional comfort. Other paintings of Pollock contain time, our own era with valuable elements of other eras revalued, but *Number 29* is a work of the future; it is waiting. Its

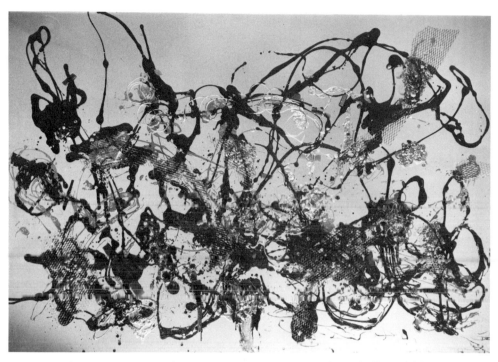

15. *Number 29*, 1950. Oil paint, wire mesh, string, shells, pebbles on glass, 48″ × 72″. Collection, National Gallery of Canada, Ottowa.

reversible textures, the brilliant clarity of the drawing, the tragedy of a linear violence which, in recognizing itself in its own mirror-self, sees elegance, the open nostalgia for brutality expressed in embracing the sharp edges and banal forms of wire and shells, the cruel acknowledgment of pebbles as elements of the dream, the drama of black mastering sensuality and color, the apparition of these forms in open space as if in air, all these qualities united in one work present the crisis of Pollock's originality and concomitant anguish full-blown. Next to *Number 29,* Marcel Duchamp's famous work with glass seems mere conjecture, a chess-game of the non-spirit. This is one of the works of Pollock which it is most necessary to ponder deeply, and it is unfortunate for the art of the future that it is not permanently (because of its fragility) installed in a public collection.

Scale, size and violence

Pollock has done paintings of enormous size, as have most of the recent abstract painters in America. In Europe there seems to be a general belief that if a painting is $7′ × 10′$ or over, it naturally must have been

painted by an American. And the size of the painterly projection *is* a significant characteristic of Action Painting or Abstract Expressionism.

As the critic Clement Greenberg pointed out almost a decade ago, the New York School was early involved in the conception of the "wall" as opposed to that of the "easel." This may have come from the participation of so many of these artists in the Federal Arts Project which, in basic accord with the aims, if not the ideology, expressed in Rivera's previously quoted remark, had undertaken a large program of murals for public buildings. The theory behind this was, I imagine, less spiritual than that of Rivera: if the taxpayer is paying for the art it should be available to the taxpayer, physically at the very least. Clement Greenberg has noted that Pollock worked as an easel painter on the Federal Arts Project, but many other painters, among them Arshile Gorky and Willem de Kooning, worked on the mural projects, and undoubtedly this experience had an effect on the pictorial ambitions of the New York School. Certainly the great $9' \times 17'$ paintings of Pollock done in 1950 have the effect of murals, whether installed in a private or public collection.

Scale, that mysterious and ambiguous quality in art which elsewhere is a simple designation, has a particular significance in Pollock's work, but it has nothing to do with perspectival relationships in the traditional sense or with the relationship of the size of the object painted to the size of the object in reality. It has to do, rather, with the emotional effect of the painting upon the spectator. His explorations of this quality lead to the strange grandeur of that modestly sized, $2\frac{1}{2}' \times 2'$ painting, *Shimmering Substance* (Fig. 12), whose dispersed strokes of impasto create a majestic, passionate celebration of matter, purely by their relation to the plane and format of the picture's surface. Another use of scale is seen in *Easter and the Totem,* whose seven feet of thinly-painted, large-scale arabesques have the intimacy and lyricism of a watercolor. When we approach the all-over, "drip" paintings of 1948–50, however, a different aspect of scale is apparent.

It is, of course, Pollock's passion as an artist that kept his works from ever being decorative, but this passion was expressed through scale as one of his important means. In the past, an artist by means of scale could create a vast panorama on a few feet of canvas or wall, relating this scale both to the visual reality of known images (the size of a man's body) and to the setting (the building it would enhance). Pollock, choosing to use no images with real visual equivalents and having no building in mind, struck upon a use of scale which was to have a revolutionary effect on contemporary painting and sculpture. The scale of the painting became that of the painter's body, not the image of a body, and the setting for the scale, which would include all referents, would be the

canvas surface itself. Upon this field the physical energies of the artist operate in actual detail, in full scale; the action of inspiration traces its marks of Apelles with no reference to exterior image or environment. It is scale, and no-scale. It is the physical reality of the artist and his activity of expressing it, united to the spiritual reality of the artist in a oneness which has no need for the mediation of metaphor or symbol. It is Action Painting.

This is a drastic innovation hitherto unanticipated, even in the mural-size works of Picasso and Matisse. No wonder, then, that when these paintings were first shown in the Betty Parsons Gallery the impression was one of inexplicable violence and savagery. They seemed about to engulf one. This violence, however, was not an intrinsic quality of the paintings, but a response to Pollock's violation of our ingrained assumptions regarding scale. So impressively had Pollock expounded his insight into the qualities dormant in the use of scale that when seen only a few years later at the Janis Gallery or in The Museum of Modern Art the violence had been transmuted into a powerful personal lyricism. The paintings had not changed, but the world around them had.

Nor is the meaning of these paintings ambiguous. Each is a direct statement of the spiritual life of the artist. Each is its own subject and the occasion for its expression. There is no need for titles. This was, in fact, the "spiritual climate" of the New York School in those years, and most of the painters involved in it simply used numbers for identification of canvases, though many had previously used titles and would return to them again, as did Pollock.

Black and White

Pollock, Franz Kline, and Willem de Kooning have completely changed the concept of color in contemporary art, not by a concerted program, but by adamant individuality of interest. To generalize hastily, but I hope not unprovocatively: de Kooning, in the late 1940s and early 1950s, loved white as all-color with black as negative; Kline had an equal passion for black and for white in the works exhibited between 1951 and 1957; Pollock, following the triumphant blacks of *Number 29* and *Number 32,* both of 1950, restricted himself almost exclusively to black on unsized canvas in the 1951–52 pictures. Giving up all that he had conquered in the previous period, Pollock reconfronted himself with the crisis of figuration and achieved remarkable things. The only color that is allowed to intrude on the black stain of these figurative works is a sepia, like dried blood (*Number 11,* 1951, a monumental, moon-struck land-

35

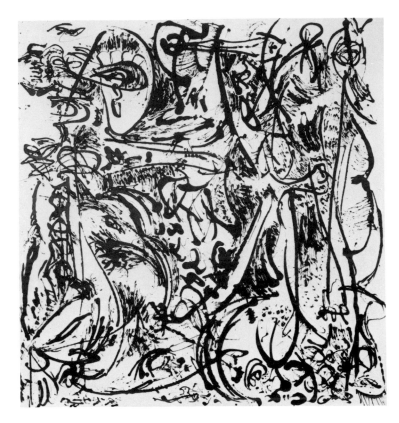

16. *Echo,* 1951, Oil on canvas,
92″ × 85¾″.
Collection,
Museum of Modern Art,
New York.
Photo, Hans Namuth.

scape) and the strange *maquillage* on the face to the right of *Portrait and a Dream,* dated 1953, but properly belonging to this group.

The wonderful draftsmanship of the early drawings and the "drip" periods is here brought to bear on heads and figures of nightmarish variety and semblance. *Echo* (Fig. 16), that effulgence of sensory indulgence, the two "heads," *Number 3* and *Number 26,* the reclining figure of *Number 14* —who makes one wonder if she is not Cassandra waiting at night in the temple of Apollo for the gift of prophecy, as does the figure in *Sleeping Effort*—the savagely (as opposed to brilliantly) virtuoso handling of spatial negation in *Number 6, 1952,* each brings an aspect of the early Pollock up-to-date, half Dionysius, half Cyclops. They are disturbing, tragic works. They cry out. What this must have meant to him after the Apollonian order of *Autumn Rhythm* is unimaginable.

The last period

Much has been written about Pollock's difficulties in the last three years of his life, and more has been spoken. The works accomplished in

17. *The Deep,* 1953.
Oil and enamel on canvas,
86¾" × 59⅛".
Collection,
Musée du Vingtième Siècle,
Place Beaubourg, Paris.

these years, if created by anyone else, would have been astonishing. But for Pollock, who had incited in himself, and won, a revolution in three years (1947–50), it was not enough. This attitude has continued to obscure the qualities of some of these works, for in *Blue Poles* (Fig. 10) he gave us one of the great masterpieces of Western art, and in *The Deep* (Fig. 17) a work which contemporary esthetic conjecture had cried out for. *Blue Poles* is our *Raft of the Medusa* and our *Embarkation for Cytherea* in one. I say *our,* because it is the drama of an American conscience, lavish, bountiful, and rigid. It contains everything within itself, begging no quarter: a world of sentiment implied, but denied; a map of sensual freedom, fenced;

18. *Easter and the Totem,*
1953.
Oil on canvas, 82 1/8″ × 57 7/8″.
Collection,
Lee Krasner Pollock,
New York.
Photo, Oliver Baker.

a careening licentiousness, guarded by eight totems native to its origins (*There Were Seven in Eight*). What is expressed here is not only basic to his work as a whole, but it is final.

The Deep is the coda to this triumph. It is a scornful, technical masterpiece, like the *Olympia* of Manet. And it is one of the most provocative images of our time, an abyss of glamor encroached upon by a flood of innocence. In this innocence, which ambiguously dominates the last works, Pollock painted his final homage to those whose art he loved and thought of in his need: the American Indian (*Ritual*), Matisse (*Easter and the Totem*) (Fig. 18), and Soutine (*Scent*). Though *Search,* for us a

difficult, for him an agonizing work, was prepared to reveal again a classical level of objectivity, a new air, a new light, the causal insight mentioned earlier was stopped by accident—that accident which had so often been his strength and his companion in the past was fatal.

As Alfonso Ossorio, his friend, fellow-painter, and collector, wrote of his paintings in 1951: "We are presented with a visualization of that remorseless consolation—in the end is the beginning.

"New visions demand new techniques: Pollock's use of unexpected materials and scales is the direct result of his concepts and of the organic intensity with which he works, an intensity that involves, in its complete identification of the artist with his work, a denial of the accident."

And his work does deny accident. It is as alive today as when, in 1947, Pollock wrote:

My painting does not come from the easel. I hardly ever stretch my canvas before painting. I prefer to tack the unstretched canvas to the hard wall or the floor. I need the resistance of a hard surface. On the floor I am more at ease. I feel nearer, more a part of the painting, since this way I can walk around it, work from the four sides and literally be *in* the painting. This is akin to the method of the Indian sand painters of the West.

I continue to get further away from the usual painter's tools such as easel, palette, brushes, etc. I prefer sticks, trowels, knives and dripping fluid paint or a heavy impasto with sand, broken glass and other foreign matter added.

When I am *in* my painting, I'm not aware of what I'm doing. It is only after a sort of "get acquainted" period that I see what I have been about. I have no fears about making changes, destroying the image, etc., because the painting has a life of its own. I try to let it come through. It is only when I lose contact with the painting that the result is a mess. Otherwise there is pure harmony, an easy give and take, and the painting comes out well.*

This is the affirmation of an artist who was totally conscious of risk, defeat, and triumph. He lived the first, defied the second, and achieved the last.

* From *Possibilities 1,* 1947–8, "Problems of Contemporary Art," v. 4, New York, George Wittenborn, Inc.

Franz Kline

Introduction and Interview

Among the American artists to emerge after World War II, Franz Kline occupied a stellar position. Soon after his first one-man exhibition in 1950 at the Charles Egan Gallery in New York, he took a firm, if controversial, place in the consciousness of artists and collectors. Public recognition was slower to come, but his next exhibition a year later placed Kline in the company of Pollock, de Kooning, Gottlieb, Rothko, and Still, as one of the formative elements in a cultural development which was later to be unified under the various critical banners of Abstract Expressionism, Action Painting, or more simply "American-type Painting."

To Kline, as to Gertrude Stein, art meant power, power to move and to be moved. (He once said of Josef Albers, "It's a wonderful thing to be in love with The Square.") He is the Action Painter *par excellence*. He did not wish to be "in" his painting, as Pollock did, but to create the event of his passage, at whatever intersection of space and time, through the world. Each painting is a complete and open declaration of feeling. Like a conjurer, and with a similarly self-restricted cast of images, Kline chose to ring the infinite changes of delight, and metamorphosis, and pain. If painting was a wall to him, as several of his titles indicate, it was a wall

40

upon which he, as the mime, would appear in full to reveal the secret of The Dream, that dream of power which shuns domination and subjection and exists purely to inspire love.

Kline had had a thorough academic art training and, unlike many of the artists associated with him, served a long apprenticeship in devotion to traditional forms and styles. He was about thirty-seven when his own personal style began to emerge. As Elaine de Kooning, the painter and his close friend, recalls:

> While young Americans in the late 'thirties were reacting variously to School of Paris and Mexican art, Franz was in London, poring over the work of English and German graphic artists and cartoonists with their references to Daumier, Blake, Fuseli, Rowlandson, Dürer and Goya, and collecting old prints of the Japanese.
>
> In the early 'forties, when New York galleries and museums were devoted to Picasso *et al.*, Franz was entranced with Velasquez, Rembrandt, Vermeer, Corot, Courbet, Manet and with the introverted American landscape painters, Ryder, Blakelock and Wyant. When he did yield to twentieth-century styles in the mid-forties, it was with reservations, as though he viewed them through a scrim in a previous style.*

And of course it was precisely such a scrim which enabled Kline and Pollock to share such a tremendous admiration for a painter like Ryder and find such totally different inspirations in his work.

When Kline returned to America from England in 1939 his career as a serious artist began, and it was as a serious Bohemian artist. Where Gorky and de Kooning had already established a highly intellectual aura of esthetic investigation, discovery, and discussion, Kline's temperament and style developed more slowly away from the works of the past he so loved, and he himself was attracted more to the style of the boulevardier, insofar as an artist during the Great Depression could afford to be, frequenting the cafés and bars of Greenwich Village. While most of the artists with whom he would later be associated in the public's mind were employed on one or another of the painting projects of the United States Government, Kline was fortunate in receiving help and support during these years of severe financial struggle from two patrons, Dr. Theodore Edlich, his family's physician, and the industrialist I. David Orr, both of whom purchased and commissioned numerous early figurative works.

During these years Kline exhibited in the twice-yearly shows held on the sidewalks surrounding Washington Square, a Greenwich Village tradi-

* de Kooning, Elaine. "Franz Kline: Painter of his own life," *Art News* 61, no. 7, pp. 28–31, 64–69 ill., port., Nov. 1962.

tion still very much alive today. He painted a series of murals depicting vaudeville and burlesque scenes for the Bleeker Street Tavern, and drew caricatures of its patrons for the nearby Minetta Tavern. Fortunately many of these works have been preserved and in them, in contrast to the studio paintings of the period, we find the first hints of the Expressionist pace and ready confrontation, and that embrace of vulgarity and drama, which were later to emerge transformed into a new boldness of stance in Kline's abstract work of the fifties. In the studio he painted numerous portraits and seated figures, the latter usually in a rocking chair—and memories of the Pennsylvania landscape and of the trains which carried coal from the mines are among the earliest motifs. Even later, when the transformation from the traditional landscape of Post-Impressionism into a powerful personal vehicle of expression had occurred in his painting, Kline still liked to assign Pennsylvania place-names to abstract paintings (*Lehigh*—Fig. 1, *Shenandoah,* or *Hazleton,* for example), or names of locomotives remembered from his youth (*Chief, Cardinal*). However, it would be a mistake to read into the forms of the later paintings any significant literary meaning from the titles, applied as they were after the fact of the paintings' creation.

Above all, he drew constantly, whether in a studio, café, or street, with whatever materials were available. In his own studio he frequently used the pages of a telephone book to catch an idea or to test a gesture or a motion; elsewhere menus, napkins, or scraps of paper would be used and saved for further thought. Drawing for Kline represented not only an activity, but also a diary of plastic notions which might be resumed and developed years later, or acted upon immediately. It follows then that many of the drawings indicated as "studies" are more properly events preceding or related to a given oil painting or mimetic rehearsals of gesture awaiting their ultimate and ideal scale, rather than studies in the traditional sense.

Kline loved paradoxes and theatrics: a great mime, he was fond of parodying, often wordlessly, always amiably, friends, artists, collectors, museum officials, or further afield, literary figures and performers he remembered from vaudeville and the circus. He unerringly, and with great affection, picked upon the precise eccentricity or foible which made his particular subject unique. Alone he was serious, attentive, philosophical within a wonderfully idiosyncratic frame of reference which placed his own conception of The Dream (of art and life) on an equal semantic footing with Existentialism and the Absurd; in public he was gregarious, a marvellous raconteur, and a tremendous fan of Mae West and W. C. Fields. He personally held at bay all possibilities of self-importance, pomposity, mysticism, and cant which might have otherwise interfered

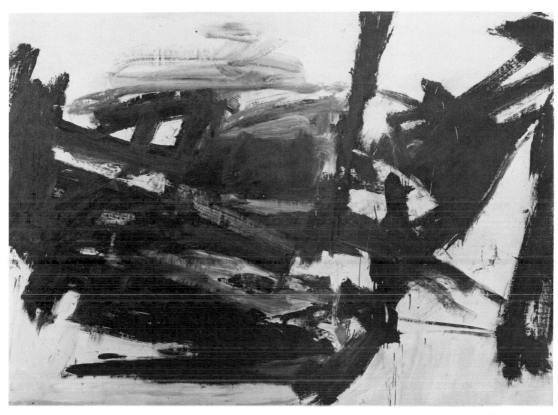

1. *Lehigh*, 1956. Oil on canvas, 81″ × 113⅜″.
Collection, Mr. and Mrs. Burton Tremaine, Meriden, Connecticut.

with the very direct and personal relation he had to his paintings and their content. He kept himself from being publicly engulfed by his own meanings and the meanings he so well intuited in the life around him. He did not tame his work, but he thus tamed the role which he suspected so correctly society would, if allowed, impose upon him as it had on the unsuspecting Pollock. One of the lessons of our own society, often as opposed to that of Europe in the very recent past, is that for the artist to keep working after initial recognition he must adopt the cleverest devices of Dickens's Artful Dodger. Kline worked publicly to retain his studio privacy. No matter how helplessly he and those around him dissolved in laughter at one of his fantastic anecdotes, underlying it was a nostalgia and longing which reminded one of the early "idealistic" anarchists, and a melancholy recognition of mutability, self-irony singling out the irony of the specific tale.

In a sense the figurative paintings of the forties, fanatically worked

43

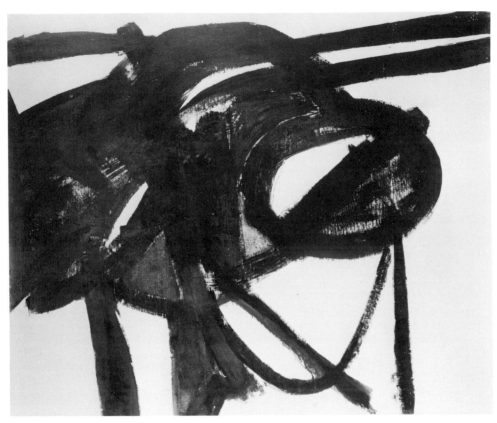

2. *Chief,* 1950. Oil on canvas, 58⅜″ × 73½″.
Collection, The Museum of Modern Art, New York;
gift of Mr. and Mrs. David M. Solinger.

over and over if they did not "make something happen," are his own exhaustions of appearances which haunted him. At this time Kline was teaching himself what he saw and what he could do and what he wanted to see. He loved relationships, if not imitations. He loved commissions as a challenge for his talents, and the more specific the commission the more challenged he felt. "You know I was very hard up one time and this collector was dying to have a Laurencin over his fireplace. He asked me if I could paint him one and I said I'd try. You know, it was terrific working on it, and it turned out to be a terrific picture, all pink and white. I kind of like Laurencin anyway; like Apollinaire said, she was an Amazon."

But once he had found what he wanted to see in his drawings, this fun in art, and this kind of versatility, El Greco and Cézanne in the land-

scapes, Pascin and Soutine in the figures, were put behind him. The modest quality remained in his conversation, but in his art he was on stage at last with all his own juggler's paraphernalia and the opportunity for great risks and great achievements was fully apparent to him in the harsh light.

Unlike many of his contemporaries, Kline was never consciously avant-garde. He had none of the polemical anxiety which must establish itself for a movement or style and against any or all others. His great admiration for de Kooning did not preclude an intense admiration for Pollock, even in a close-knit artistic society full of partisanship and either/or decisions, which gathered frequently at The Club, an artists-sponsored meeting place, or at a nearby bar, to engage in heated discussions of esthetic right and wrong. His combats were with himself in his art, and were so personal as to defy intellectualization.

His first significant abstract works were done about 1945–47. They evolved naturally from preoccupation with the act of drawing. The "break-through" in style, which seemed to have been signalled in 1950 in his first one-man exhibition, is already foreseen in two works of 1947, *Collage,* which prefigures many of the later large horizontal paintings, and *Untitled,* with its strong relationship to both *Chief* (Fig. 2) and *Clock Face.* The later works, done in black and white, established Kline's originality and strength, but the motifs already existed in the earlier colored ones.

However, the scale marks a change in Kline's self-orientation. In the late forties de Kooning had done a series of black-and-white abstract paintings in enamel with shiny surfaces and the marvellously acute calligraphic cuttings and whippings of line for which he is famous, and Pollock was soon to embark on his series of semifigurative works done with black paint seeping into unsized canvas, at once sensitive in surface and frequently grotesque in form. Kline's was an entirely different approach to black and white. The forms are stark and simple, the gesture abrupt, rough, passionately unconcerned with finish. All the finesse so ardently acquired from the masters has been set aside for a naked confrontation with the canvas and the image. Where finesse still exists, as in *Cardinal* and *Abstraction* 1950–51, it is commanded by the image totally. The images have become hieratic and undeniable, composed of monumentally angular calligraphic strokes in constant tension with a rough and awkward semigeometrical stubbornness, like a struggle between Picasso's *Guernica* and the Bauhaus. *Wotan* (Fig. 3) is an example of the uncompromisingly successful outcome of this impulse.

In the mid-fifties Kline enlarged enormously the scope of his expres-

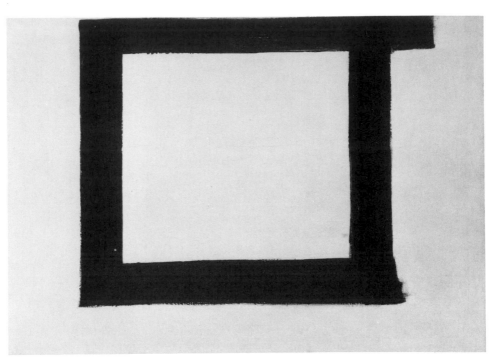

3. *Wotan,* 1950. Oil on canvas on masonite, 55⅛″ × 79⅜″.
Courtesy, Denise René Galleries, Paris, New York, Dusseldorf.

sion without losing any of the immediacy and vigor of his painterly
gesture. His blacks and whites took on more and more variety of hue,
and their relationships as colors, as in *White Forms,* became the vehicle
for the introduction of browns and umbers in *The Bridge* and *Shenan-
doah,* culminating in 1958 in *Mycenae,* where black is entirely absent, and
the slashing strokes of reds and yellows interact with the whites in the
same intensely opposite way as do the blacks and whites in the earlier
paintings.

Paradoxically, the introduction of reds, purples, oranges, and
browns into the paintings of this period met with as much controversy as
had Kline's initial insistence on their absence. Having been assigned the
kingdom of black and white, this seemed like abdication. But Kline's
greatest efforts were always engaged in pictorial problems, rather than the
pursuit of perfection. He was not at all interested in pursuing a style
toward the dead-end of expertise. When problems did not exist, he
created them. Even in the black-and-white paintings of this period we
note the increasingly more frequent use of grays, blue-grays, charcoals,
altering and complicating the previously clearly defined relationships in a

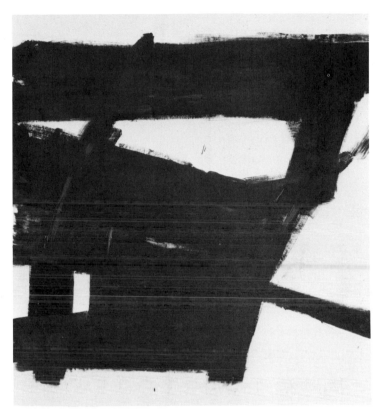

4. *Wanamaker Block*, 1955.
Oil on canvas, 78½″×71″.
Collection,
Richard Brown Baker.
Photo,
Yale University Art Gallery.

manner which has more to do with chiaroscuro and sfumato than simply with obscured calligraphy. A masterpiece like *Wanamaker Block* (Fig. 4), one of his most characteristic black-and-white paintings, seems the direct and inevitable result of a natural gift, but for Kline it was a hard-won battle, and he distrusted easy victories. To the difficult victories we owe the Kline of *Lehigh* and *Rue,* with their changes from stark opposition of line and mass toward nuances of directional structure and developments of spatial ambiguities within the mass.

To those who had thought the early paintings were influenced by Japanese calligraphy the more complicated hues in the paintings of the mid- and late-fifties were puzzling. But as the density and complexity of Kline's content deepened from embattled clarity to tragic awareness, the means of a previous feeling could not be simply restated in another context. Nor had the earlier work been actually calligraphic in the Oriental sense. The whites and blacks are strokes and masses of entirely relevant intensity to the painting as a whole and to each other. The strokes and linear gestures of the painter's arm and shoulder are aimed at an ultimate

structure of feeling rather than at ideograph or writing. Unlike Tobey, Kline did not find a deep spiritual affinity in Japanese art, beyond his appreciation of its pictorial values and perhaps a fondness for the diagonal and for the build-up of unified imagery through exquisite detail also appreciated fully by so many nineteenth-century European painters. His influence on Japanese painters themselves has usually led them directly *away from* their own calligraphic tradition, and we know that one of their leading painters, the late Sabro Hasegawa, admired Kline precisely because his work seemed so uniquely American.

He had always, however, the draftsman's gift of placement. Forms, strokes, dots, and dabs found unerringly their ideal position in the space of his surfaces. He was very conscious of this quality, and of the vitality and freshness of a slightly "off" positioning. His consciousness of the limits of the canvas was that of the high-diver to his pool, the aerialist to his net. The range of his perception of presences was extraordinary. Some come toward you, advancing as you are beckoned, some implacably turn away from your descent while others float, implacably waiting, or speed past in panoramic darkness. The huge organic lunge of *Orleans,* the massive gates of *Zinc Door* with the exiled yellows above them, the dignified, impassive guardedness of *Slate Cross,* are all aspects of a rigorous confrontation with extreme experiences. These late, great structures of his mind, lucid, tangible, and fiercely humane in their sweeping inclusiveness, find ultimate expression in such a painting as *Shenandoah Wall* (Fig. 5), a frontier which fate was to prevent the artist from crossing into who knows what other land of promise?

The following interview was done in 1958, at one sitting. The initial reference is to an abstract painting by Willem de Kooning, c. 1945, which was in the room during the interview. Since the painter felt that set questions were too stilted for him, the agreement was that he "would just start talking."

FRANZ KLINE: That's Bill's isn't it? Terrific! You can always tell a de Kooning, even though this one doesn't look like earlier ones or later ones. It's not that style has a particular look, it just adds up. You become a stylist, I guess, but that's not it.

Somebody will say I have a black-and-white style, or a calligraphic style, but I never started out with that being consciously a style or attitude about painting. Sometimes you do have a definite idea about what you're doing—and at other times it all just seems to disappear. I don't feel mine is the most modern, contemporary, beyond-the-pale, *gone* kind of painting.

48

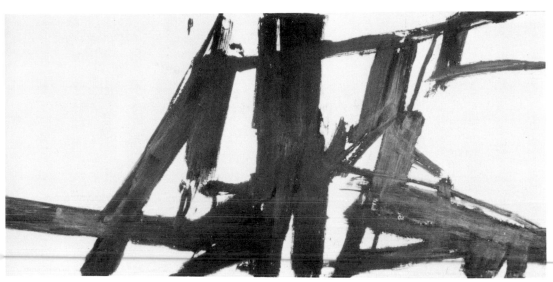

5. *Shenandoah Wall,* 1961. Oil on canvas, 80¾″ × 171″.
Courtesy, Allan Stone Gallery.

But then, I don't have that kind of fuck-the-past attitude. I have very strong feelings about individual paintings and painters past and present.

Now, Bonnard at times seems styleless. Someone said of him that he had the rare ability to forget from one day to another what he had done. He added the next day's experience to it, like a child following a balloon. He painted the particular scene itself: in form, the woman can't quite get out of the bathtub. And he's a real colorist. The particular scene itself? Matisse wouldn't let that happen, he didn't let himself get too entranced with anything.

In Braque and Gris, they seemed to have an idea of the organization beforehand in their mind. With Bonnard, he is organizing in front of you. You can tell in Léger just when he discovered how to make it like an engine, as John Kane said, being a carpenter, a joiner. What's wrong with that? You see it in Barney Newman too, that he knows what a painting should be. He paints as he thinks *painting* should be, which is pretty heroic.

What with the drying and all, you can tell immediately pretty much whether a painting was done all at once or at different intervals. In one Picasso you can see it was all immediate, spontaneous, or in another that he came back the next day and put on the stroke that completed it. Sometimes you get one of those dark Ryders; it's the top one and it's all spontaneous and immediate, done all at once, and there are seven or eight others underneath it you can't tell about.

49

Now I'm not saying that doing it all at once implies an idea of the organization beforehand or that you like it when it's done all at once or that you like it when you've had the idea before you began. You instinctively like what you can't do. I like Fra Angelico. I used to try all the time to do those blue eyes that are really blue. Someone once told me to look at Ingres. I loved Daumier and Rembrandt at the time and I was bored when I looked at Ingres. Before long I began to like it. You go through the different phases of liking different guys who are not like you. You go to a museum looking for Titian and you wind up looking at someone else. But the way of working before Cézanne is hidden. Cézanne is like an analyst and he seems to be right there, you can see him painting the side of a nose with red. Even though he wanted to paint like Velasquez.

They painted the object that they looked *at*. They didn't fit out a studio and start painting without a subject. I find that I do both. Hokusai painted Fuji because it was there. He and others remembered it and drew from their imagination of how they had tried to paint it when it was in front of them. When he paints Fuji with a brush—birds, mist, snow, etc.—its not the photographic eye but his mind has been brought to the utter simplification of it, and that doesn't bring it into symbolism. With Hokusai it was more like Toulouse-Lautrec drawing dancers and wanting to draw like Degas who wanted to draw like Ingres. It has something to do with wanting to see people dance. Or like Rembrandt going to see Hercules Seghers' landscapes.

Malevich is interesting to me. Maybe because you are able to translate through his motion the endless wonder of what painting could be, without describing an eye or a breast. That would be looking at things romantically, which painters don't do. The thing has its own appeal outside of the white-on-white, this-on-that idea. With Mondrian, in a way you see that the condition is that he's a guy who solves his own problems illogically. He's done it with paint illogically to himself—which makes it logical to some other people. I was at the studio of one of these people one day and he said he was going to put red in one of the squares to improve it and what did I think? I said try it out and see if you like it, not if it improves it.

There's this comedian I know in the borscht circuit. They had a theater group and everything up there and my friend asked me to go there and teach painting. I told him I didn't have the money to get there and he said he'd send it to me. I got up there and talked with this comedian. He had studied with Raphael Soyer and painted, but he never could sell anything, so he took this job as a comedian and never got back to painting. He loved Jackson Pollack and had such marvellous heart about it all that he could never have been popular at either painting *or* comedy. He *cared*

so much. Somebody did an imitation of my drawing on a napkin, laughing, six lines, and said, "That's all there is to it." My friend said, "That's why I like it."

Then of course there are reviewers. I read reviews because they are a facet of someone's mind which has been brought to bear on the work. Although if someone's against it, they act as if the guy had spent his life doing something worthless.

Someone can paint *not* from his own time, not even from himself. Then the reviewer cannot like it, maybe. But just to review, like a shopper, I saw one this, one that, good, awful, is terrible. Or he may be hopelessly uninterested in what it is anyway, but writes about it. I read Leonard Lyons in the john the other day and he said every other country picked out the best art for the Venice Biennale, but we didn't. Then someone in the government went to Brussels and said painters should have to get a licence for buying brushes. Lyons went on to say he hoped that there will be a day when abstractions are not supposed to be made for a child's playroom.

Criticism must come from those who are around it, who are not shocked that someone should be doing it at all. It should be exciting, and in a way that excitement comes from, in looking at it, that it's *not* that autumn scene you love, it's *not* that portrait of your grandmother.

Which reminds me of Boston, for some reason. You know I studied there for a while and once later I was up there for a show and met this Bostonian who thought I looked pretty Bohemian. His definition of a Bohemian artist was someone who could live where animals would die. He also talked a lot about the 8th Street Club and said that Hans Hofmann and Clem Greenberg run it, which is like Ruskin saying that Rowlandson and Daumier used up enough copper to clad the British Navy and it's too bad they didn't sink it. Why was he so upset about an artists' club in another city? You get classified as a New York painter or poet automatically. They do it in Boston or Philadelphia, you don't do it yourself.

Tomlin. In a way, they never did much about him and I think it's sad. He didn't start an art school, but he had an influence—his statements were very beautiful. When Pollock talked about painting he didn't usurp anything that wasn't himself. He didn't want to change anything, he wasn't using any outworn attitudes about it, he was always himself. He just wanted to be in it because he loved it. The response in the person's mind to that mysterious thing that has happened has nothing to do with who did it first. Tomlin, however, did hear these voices and in reference to his early work and its relation to Braque, I like him for it. He was not an academician of Cubism even then, he was an extremely personal and sensi-

51

tive artist. If they want to talk about him, they say he was supposed to be Chopin. He didn't knock over any tables. Well, who's supposed to be Beethoven? Braque? I saw Tomlin's later work at the Arts Club in Chicago when he was abstract and it was the most exciting thing around—you look up who else was in the show.

If you're a painter, you're not alone. There's no way to be alone. You think and you care and you're with all the people who care, including the young people who don't know they do yet. Tomlin in his late paintings knew this. Jackson always knew it: that if you meant it enough when you did it, it will mean that much. It's like Caruso and Bjoerling. Bjoerling sounds like Caruso, but if you think of Caruso and McCormack you think of being in the world as you are. Bjoerling sounded like Caruso, but it turned out to be handsome. Bradley Tomlin didn't. Unless. . . . Hell, if you look at all the painting in the world today it will probably all turn out to be handsome, I don't know.

The nature of anguish is translated into different forms. What has happened is that we're not through the analytical period of learning what motivates things. If you can figure out the motivation, it's supposed to be all right. But when things are "beside themselves" what matters is the care these things are given by someone. It's assumed that to read something requires an ability beyond that of a handwriting expert, but if someone throws something on a canvas it doesn't require any more care than if someone says, "I don't give a damn."

Like with Jackson: you don't paint the way someone, by observing your life, thinks you *have* to paint, you paint the way you have to in order to *give,* that's life itself, and someone will look and say it is the product of knowing, but it has nothing to do with knowing, it has to do with giving. The question about knowing will naturally be wrong. When you've finished giving, the look surprises you as well as anyone else.

Of course, this must be an American point of view. When Delacroix talks about the spirit, it must be French. It couldn't be Russian or Japanese. But writing his journals doesn't make him knowledgeable or practical. Delacroix was more interesting than that. That isn't the end in relation to his paintings. If it had been the end, people would have thought it interesting. Some people do think so.

Some painters talking about painting are like a lot of kids dancing at a prom. An hour later you're too shy to get out on the floor.

Hell, half the world wants to be like Thoreau at Walden worrying about the noise of traffic on the way to Boston; the other half use up their lives being part of that noise. I like the second half. Right?

52 To be right is the most terrific personal state that nobody is interested in.

David Smith

Smith was a very strong individualist and a very strong moral force in American art. He was considered by many to be the finest sculptor North America has produced; his death in 1965 in an automobile accident, as had Jackson Pollock's earlier, assumed for many a symbolic as well as tragic significance. A great and vital force, who like Pollock had given inspiration and esthetic confidence to many other artists, was suddenly gratuitously removed from American art. Unlike Pollock, Smith died at the height of his productivity. In 1962, thanks to the accommodations of the Italian steel producing company Italsider, S.p.A., and the workmen in its factory at Voltri, he had created twenty-six sculptures in thirty days, ranging in importance from superb to no less than significant. This same prodigal approach to sculptural ideas long fermenting within him continued when he returned from Italy, though naturally the same incredible pace was not maintained without the resources placed at his disposal by Italsider and the Italian government. But renewed freshness and vigor had come from this experience, and after the showing of the works at the Festival of Two Worlds in Spoleto, he returned to America to commence work on bronzes, on small painted steel pieces (the

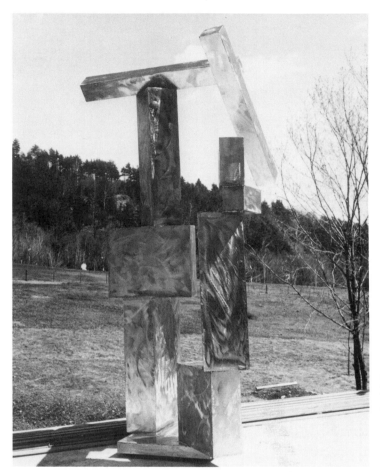

1. *Cubi IX,* 1961.
Stainless steel,
106¼″ × 56″ × 46″.
Collection,
Walker Art Center,
Minneapolis, Minn.
All Smith photographs courtesy
David Smith Papers,
Archives of American Art,
Smithsonian Institution.

"Menand" series), on the heroic stainless steel series called "Cubi" (Fig. 1), on three huge *Wagons,* inspired by one he had made in the Voltri factory, and on the "Voltri-Bolton" series, homages to the experiences and materials he had found so inspiring during his work in Italy. A week or so before he died, in the midst of preparations for an exhibition of the *Cubis* at the Los Angeles County Museum, he spoke of plans for one or two more "gate-type" *Cubis,* a twenty-foot-high stainless steel *Tower* (its parts already laid out in a preliminary stage on the terrace of his workshop), and a *Zig* "as big as a locomotive engine."

This intense productivity was not, however, a late development in his career. Through the last twenty-five years of his life, the home, studio, and workshop at Bolton Landing, in the beautiful mountains above Lake George in northern New York State (near Canada), had gradually filled with sculptures which spilled out onto the hill on which the house was

54

situated. In the early days he had begun to place sculptures outdoors in the fields for lack of indoor storage space and in order to study them in an unconfined and uncluttered area. Later he built cement pedestals in the fields where sculptures became a permanent feature, constantly replaced by newer work. With the hundreds of sculptures and paintings, and some three thousand drawings done in his solitude at night or when the weather prevented his working on sculptures, Bolton Landing became an extraordinary one-man museum. Since Smith did not begin to sell significantly until relatively late in his career, and because of his desire to retain certain key works of each period for his two young daughters, the collection at Bolton Landing comprised a nearly complete survey of every aspect of his gifts and interests, as well as many intriguing diversions of his talents. Approaching it, one was struck by these brilliant and sophisticated stainless steel or painted structures, poised against the rugged hills and mountains, the lake in the distance, and the clouds, an assertion of civilized values not nearly so surprising in the confines of a gallery or museum, where, conversely, these same sculptures took on an aspect of rugged individualism and often an almost brutally forthright power. This was also true of Smith the man. At a party or a *vernissage* in New York he appeared a great, hulking, plain-spoken art-worker out of Whitman or Dreiser, neither impressed nor particularly amused by metropolitan "light-weight" manners, somewhat of a bull in a china shop; at his home in Bolton Landing, with the same "plain" manner, he prepared delicious meals himself, offered excellent wines and cigars, and spoke of his love of Renaissance music (particularly Giovanni Gabrieli) and Mozart and the writings of James Joyce, of his interest in the musical ideas of John Cage, in the dancing and choreography of Merce Cunningham, in the poetry of Dylan Thomas and William Carlos Williams, in the work of younger artists, particularly, as I remember, the sculptors John Chamberlain, Mark di Suvero, and Anthony Caro, and the painter Kenneth Noland, who had influenced his conception of the "Circle" series. On walks he might discuss Egyptian and Sumerian art (his "Zig" series was inspired by the latter and, I believe, also the "Cubi" series), local politics (he had run for public office in Bolton Landing, but not been elected), the cult of Marilyn Monroe (with which he was in complete and enthusiastic sympathy), what you yourself had been working on recently and the difficulties involved. His compressed time-sense and his attention to both scholarly and immediate experiences is best expressed in his own words:

The stream of time and the flow of art make it plain that no matter what the sculptor's declaration of individual vision he cannot conceive outside his time. His art conception takes place in dialectic order. The flow of art, the

time of man, still places him within his own period, out of which he cannot fly, and within which all other men exist. For no object he has seen, no fantasy he envisions, no world he knows, is outside that of other men. No man has seen what another has not, or lacks the components and power to assemble. It is impossible to produce an imperceptible work . . .

Practically, the law of gravity is involved, but the sculptor is no longer limited to marble, the monolithic concept, and classic fragments. His conception is as free as the painter's. His wealth of response is as great as his draughtsmanship. Plastically he is more related to pagan cultures with directives from cubism and constructivism.[1]

As an affirmation of his contemporaneity, Smith found it only natural to range freely from Mesopotamia to Paris, from the Lascaux caves to the most recent painting exhibition of his friend Helen Frankenthaler, on each of which he had equally passionate opinions and insights.

Smith was born in the Midwest in 1906. (Knowing that I was brought up in mountainous New England, he once told me that no one not born in the "flatlands" of the Midwest could appreciate the thrill that the mountains of Bolton Landing had for him or just how inspiring to him that space was.) He spent his youth in Decatur, Indiana, where "everyone in town was an inventor. There must have been fifteen makes of automobiles in Decatur, Indiana; two blocks from where I lived there were guys building automobiles in an old barn. Invention was the fertile thing then . . ."[2] He himself took an early interest in drawing and making signs and cartoons. He attempted to study art, but found the available curricula unsatisfactory.

At the age of nineteen he took a job in an automobile plant in South Bend, Indiana, thus beginning the development of skills which would later serve him as a sculptor and even direct his impulses toward technical innovation in steel sculpture, though at the time his inclination was growing toward being a painter.

A year later, after a brief stay in Washington, D. C., he moved to New York City, where he had the good fortune to meet the painter Dorothy Dehner, who was to be his first wife and who is now also a distinguished sculptor. Miss Dehner persuaded him to attend classes at the Art Students League. Once established as a student at the League, Smith encountered further good fortune in meeting the Czech abstractionist Jan Matulka, then teaching at the League, who introduced him to the works of Picasso, Mondrian, Kandinsky, Malevich, and Lissitzky—since the general tenor of art instruction in America at the time was provincial and

[1] "Who is the artist? How does he act?" *Numero,* no. 3, May–June 1953, p. 21.
[2] "The Secret Letter, An Interview with David Smith," June 1964. Thomas B. Hess. In *David Smith,* New York, Marlborough-Gerson Gallery, October 1964.

traditionalist, this encounter was of great importance. Shortly after, he became acquainted with painters who were to have a major role in the development of modern American art: John Graham and Jean Xceron, both liaisons with the avant-garde movements in Paris, and the New York-based painters, Stuart Davis, Arshile Gorky, and Willem de Kooning. All devoured the reproductions in *Cahiers d'art* and the texts in *transition,* thus turning away from the main impulses of American artistic thought of the period, saving that of the American expatriates.

Of this period, Smith wrote later: "One did not feel disowned—only ignored and much alone, with a vague pressure from authority that art couldn't be made here. It was a time for temporary expatriates, not that they made art more in France, but that they talked it . . . Their concept was no more *avant* than ours, but they were under its shadow there and we were in the windy openness here. Ideas were sought as the end, but the result often registered in purely performance. Being far away, depending upon *Cahiers d'art* and the return of patriots, often left us trying for the details instead of the whole. I remember watching a painter, Gorky, work over an area edge probably a hundred times to reach an infinite without changing the rest of the picture, based on Graham's recount of the import in Paris on the "edge of paint." We all grasped on everything new, and despite the atmosphere of New York, worked on everything but our own identities."

Smith was then a painter twenty-four years old. In the next year, 1931, he began to attach materials and then objects to the surface of his paintings, then constructed painted wooden objects. By 1932 he had begun making welded steel structures under the influence of reproductions of the works of Gargallo, Picasso, and Gonzalez, and the Russian Constructivists, retaining nevertheless his close relation to the flat surface of painting, the desire to incorporate color in his emerging sculptural ethos, and a consuming interest in Cubist esthetics. "While my technical liberation came from Picasso's friend and countryman Gonzalez, my aesthetics were more influenced by Kandinsky, Mondrian, and cubism. My student period was only involved with painting. The painting developed into raised levels from the canvas. Gradually the canvas became the base and the painting was a sculpture. I have never recognized any separation except one element of dimension. The first painting of cave man was both carved line and colour, a natural reaction and a total statement . . . I do not recognize the limits where painting ends and sculpture begins." This conviction continues into the painting of the late *Zigs,* and has everything to do with the burnishing of the stainless steel surfaces of the "Plane" and "Cubi" series, and the deliberate rusting of the *Voltri-Boltons.*

In addition to the influence of Cubism and Constructivism on

Smith's work, the influence of Surrealism cannot be underestimated. Unlike many other American artists, Smith seems to have gotten no romantic aura from Surrealism and no social or intellectual glamour: rather, he took its ideas as a development out of Freud, a serious rather than fanciful one, and in the late thirties he utilized the Surrealist vocabulary of forms (he was somewhat influenced at the time by Giacometti, Laurens, and Lipchitz) more as a means of social protest prompted by the years of the U.S. financial depression and the imminence of war than as an expression of any personal subconscious revelation. There are no frivolities and no self-indulgences in the works of this period, as there were in so many other American Surrealist-inspired works: though not his most significant works, the *Medals for Dishonor* (Fig. 2) are extraordinary technically, and most of Smith's other sculptures of the period carry an indictment of war and Fascism which is marred in its expressive conviction only by a kind of plastic self-consciousness. While one does not doubt the sincerity of the sentiment, for the only time in Smith's career, one doubts the sculpture itself, in which his high purpose seems lowered to that of propaganda, a realization he himself reached later. He went on instead to the exploration of his own identity and the discovery of his own imagery, perhaps here for the first time approaching the original impulse of Surrealism, but by exploring the vocabularies of all the contemporary styles compatible with his aims. As the American critic Hilton Kramer wrote:

> . . . as an artist he came into the inheritance of all the modernist impulses of European art simultaneously and without having to commit himself to one over another. Moreover, he came to this inheritance under the pressure of an extreme historical moment, when the structure of society seemed as much in question as the conventional forms of native American art. There is an analogue in Smith's refusal to choose one branch of modernism over another—to become purely a Cubist *or* a Surrealist *or* a Constructivist—with the anarchism of his social views. He choose to use whatever was useful to him . . .
>
> One must add that such a freedom of choice was possible because European modernism itself had become fragmented and split into isolated impulses by the early 'thirties. Henceforth each artist was on his own in making whatever connections he could between the shattered fragments of the modern movement, and projecting out of them a new aesthetic possibility . . .
>
> In effect, he restored the Constructivist idea to the Cubist tradition, which had spawned it in the first place, and then threw in the Surrealism of his own generation for good measure. Once this synthesis was achieved, Smith moved freely in and out of figurative and non-figurative modes; heads, figures, landscapes, animal images, mythical and Surrealist fantasies,

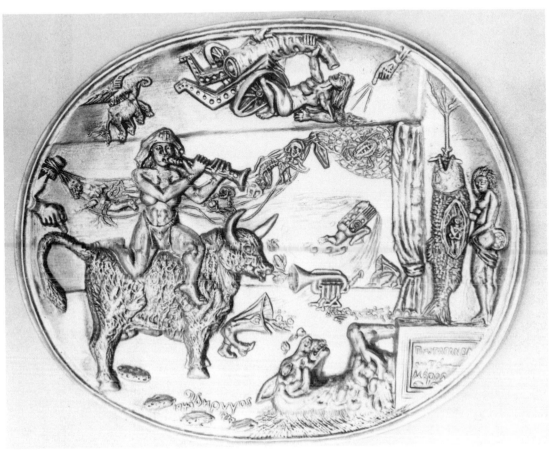

2. *Medal for Dishonor: Propaganda for War*, 1939–40. Bronze, 11⅜″ × 9⅜″. Collection, Joseph H. Hirshhorn.

the symbolic anecdote and the purely formalistic conception were all available to his medium.[3]

This freedom, however, was not so simply won at first, and Smith in the thirties was obviously casting about for the particular qualities and significant values available to him in the modes which attracted his enthusiasm, and for the means to incorporate these modes in a single, organic vision of his own originating. He had his partisans as a young artist beginning to show publicly with increasing frequency, but like de Kooning, Gorky, and Pollock, he had few, and they were largely contained within

[3] Hilton Kramer, "The Sculpture of David Smith," *Arts,* v. 34, No. 5, February 1960, pp. 22–41.

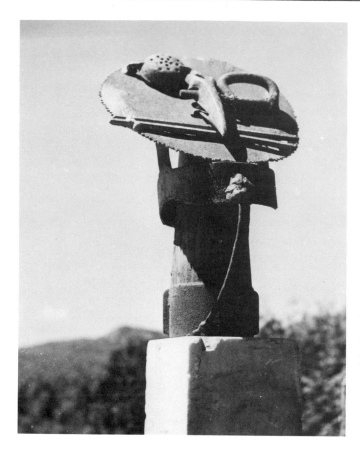

3. *Saw Head,* 1933.
Iron, painted orange and
bronze, 17″ × 11¼″ × 8¼″.
Estate of the artist.

the world of artists and a few astute collectors and critics. Restless in his
ambition and in his intellectual curiosity, he was frequently accused of
eclecticism, always a curious and confusing accusation when leveled at a
young artist.

Because of this free-ranging exploration of form, style, and medium
(his first sculpture was made in the Virgin Islands out of coral) and be-
cause of later developments in his own work and that of others, his three
"eclectic" heads of 1933, the *Agricola Head, Chain Head,* and *Saw
Head* (Fig. 3), may now be seen as works of marked originality and in-
telligence without any aura of hestitant experimentation; made from steel
and "found" steel parts, welded and painted, they establish clearly and
quickly a discourse between Smith and his own environment and show
how the formal innovations of Gonzalez and his Spanish environment en-
couraged Smith's self-searching dialogue with modern art. From the start,
Smith took the clue from the Spaniards to lead him toward the full utiliza-
tion of his factory-skills as an American metalworker, especially in the
esthetic use of steel, glorifying rather than disguising its practicality and

4. *O Drawing,* 1957. Bronze, 31″ × 50⅛″ × 9½″.
Whereabouts unknown.

durability as a material of heavy industry. By incorporating found iron and steel parts from farm implements, and factory-ordered steel parts such as I beams and concave discs in his work, Smith utilized his American milieu in much the same way that Spanish metal sculptors from Gargallo to Chillida and Chirino have utilized the traditional Spanish forging and wrought-iron techniques in developing their styles. Indeed, for all the technical delicacy and complexity of his symbolism in the late forties and the fifties, the "drawing-in-air" of such works as *Agricola IX, Parallel 42,* and *O Drawing* (Fig. 4), and the surcharged symbolic form-combinations of *Home of the Welder* (Fig. 5), *Portrait of the Eagle's Keeper,* and *Pillar of Sunday,* Smith took genuine delight in the progress of industrial technology and the new techniques it made available to him for his work. This delight, however, did not spread to reproductive methods; perhaps because of his early experience as a painter, Smith insisted adamantly that each piece be unique, finished by the artist's hand. Working in bronze, he preferred the lost wax process and created the patina himself; in other media, no matter how much assistance he needed in the

61

5. *Home of the Welder*,
1945. Steel,
21″ × 17⅜″ × 14″.
Estate of the artist.

progress of the large works, the final painting or burnishing was his own. Like the self-made man, he had the self-taught artist's pride in personal completion of each event: "Modern tools and method permit the expression of complete self-identity from start to finish. His [the contemporary sculptor's] work can show who he is, what he stands for, in many different ways and with all the fluency he desires, for every step is his own. His identity, pattern, and goal are shown in a qualitative unity, an integration stated in a manner not open to mind or hand before . . . This is, I believe, a specifically mid-twentieth-century privilege, as long as he knows the tools and materials of his time."

Another aspect of our century's privilege for Smith appears in the free play of subconscious imagery he seems to have taken for granted. The human form can be found in many abstract guises, even in works as geometrically abstract as the "Cubi" and "Plane" series, and anatomical references (to brain, heart, viscera, etc.) appear in many of the early works

6. *Leda,* 1938.
Steel, painted brown,
8½″ × 20″ × 10″.
Collection, Mr. and Mrs.
Douglas Crockwell,
1938, Glens Falls,
New York.

such as *Head as Still Life, Blackburn—Song of an Irish Blacksmith,* and the odalisque-like *Leda* (Fig. 6).

The last works of David Smith bring to startling new fruition a number of plastic ideas he had pursued with enormous variation over the years. The "Voltri-Bolton" series brings to a new height of inventiveness the combination of found and manufactured forms with his created ones, and presents a clearer vision than ever before of the possibilities of these materials. The "Cubi" series presents the stainless steel volumes balancing one on another, signalling like semaphores, climbing into the air with the seeming effortlessness and spontaneity of a masterful drawing, while retaining the sobriety of their daring defiance of gravity, a concept the meaning of which Smith had pondered often during his career both as challenge and limitation. And in the "Zig" series Smith reached the

63

peak of his effort to create monumental painted sculptures in which color becomes an organic resonance of the forms, to make sculptures which *must be* painted for their full realization. They are among his most unique accomplishments, majestic in their scale and authority, revelatory in the aspects of plane, line, and volume, which the colors enforce, outspoken in the originality and virility which they proclaim as prime values in art, yet unpretentious in the simplicity and eagerness of their expression.

A suitable epitaph for this great artist might be the words he spoke of himself a year before his death in an interview with the critic Thomas B. Hess: "You know who I am and what I stand for. I have no allegiance, but I stand, and I know what challenge is, and I challenge everything and everybody. And I think that is what every artist has to do. The minute you show a work, you challenge every other artist. And you have to work very hard, especially here. We don't have the introduction that European artists have. We're challenging the world . . . I'm going to work to the best of my ability to the day I die, challenging what's given to me." [4]

[4] "The Secret Letter," Thomas B. Hess.

Robert Motherwell

A symbolic tale of our times, comparable to the legend of Apelles' leaving his sign on the wall, is that of the modern artist who, given the wrappings from issues of a foreign review by a friend, transforms them into two collage masterpieces; and who, given a stack of Japan paper, makes six drawings and on seeing them the next day is so excited by the black ink having bled into orange at its edges that he decides to make six hundred more drawings. The collages are *N.R.F. Numbers One and Two,* the drawings are the group called "Lyric Suite," and the artist is Robert Motherwell. Does art choose the artist, or does the man choose art?

Motherwell's choice is one of the most fascinating in modern art. As a young man of twenty-five, a university student who majored in philosophy, he decided to devote himself completely to painting, a decision which at the time held promise of little but hard work and probable discouragement. Yet, a few short years later, he was to find himself one of the leading figures in the greatest revolution in modern art since Cubism, Abstract Expressionism.

Recently, in a television interview, Robert Motherwell remembered

the aims of the early period of Abstract Expressionism as being "really quite simple in a way, almost too simple, considering what has happened in the last twenty years. But really I suppose most of us felt that our passionate allegiance was not to American art or in that sense to any national art, but that there was such a thing as modern art: that it was essentially international in character, that it was the greatest painting adventure of our time, that we wished to participate in it, that we wished to plant it here, that it would blossom in its own way here as it had elsewhere, because beyond national differences there are human similarities that are more consequential. . . ." [1]

The measure of the success of the Abstract Expressionist artists may be gauged by our response to the movement's ethical stand—today it seems an inevitable development, it is surrounded by an atmosphere of "of course." But in the late thirties and early forties there was violent resistance to this "passionate allegiance." We forget, in the complexity of our present worldwide artistic and political engagements, that period's artistic and political isolationism (how controversial then were Gertrude Stein and Wendell Willkie!), the mania for the Impressionist masters, the conviction, where there was any interest at all, that avant-garde was not only a French word but an Ecole de Paris monopoly. But the greatest resistance of all came from other American painters—the regionalists, the Social Realists, and the traditionalists.

No account of the period can ignore Motherwell's role as an internationalist. In a sense a turn toward both revolution and internationalism were in the air, for the various national financial depressions had united most of the Western countries in crisis, if not in political agreement. And the artists, like the philosophers and the religious, had been the least economically valued members of distressed societies.

Without transition the struggle against Depression conditions became the struggle against war. War on such a scale that "conditions" became an obsolete word, faced down by the appalling actual and philosophical monolith of historical event. But the artists were not faced down by the war vocabulary. With the advent of war a heterogeneous number of American artists whose only common passion was the necessity of contemporary art's being modern began to emerge as a movement which, in Boris Pasternak's famous description of a far different emergency, as he relates in his autobiography *Safe Conduct,* "turned with the same side towards the times, stepping forward with its first declaration about its learning, its philosophy and its art."

[1] "Art, N.Y." Robert Motherwell interviewed by Bryan Robertson. New York, December 15, 1964 (TV broadcast produced by Colin Clark).

Underlying, and indeed burgeoning within, every great work of the Abstract Expressionists, whether subjectively lyrical as in Gorky, publicly explosive as in de Kooning, or hieratical as in Newman, exists the traumatic consciousness of emergency and crisis experienced as personal event, the artist assuming responsibility for being, however accidentally, alive here and now. Their gift was for a somber and joyful art: somber because it does not merely reflect but sees what is about it, and joyful because it is able to exist. It is just as possible for art to look out at the world as it is for the world to look at art. But the Abstract Expressionists were frequently the first violators of their own gifts; to this we often owe the marvelously demonic, sullen, or mysterious quality of their work, as they moved from the pictorial image to the hidden subject.

Motherwell's special contribution to the American struggle for modernity was a strong aversion to provincialism, both political and esthetic, a profound immersion in modern French culture (especially School of Paris art and the poetry and theories of the Symbolist and Surrealist poets—conquest by absorption, like the Chinese), and a particular affinity for what he has sometimes called "Mediterranean light," which in his paintings seems to mean a mingling of the light of the California of his childhood with that of Mexico and the south of France. This affinity may explain somewhat the ambiguity between the relatively soft painted edges of many of his forms and the hard, clear contour they convey, especially in the series of "Elegies to the Spanish Republic." He can employ a rough, spontaneous stroke while evoking from the picture plane with great economy a precise personal light. There is no atmospheric light in his paintings; if he uses gray it is never twilight or dawn. One of his important early paintings is called *Western Air* and the light in it persists in many later works.

Motherwell must have shown a surprisingly early talent for art, considering that at eleven he was awarded a fellowship to the Otis Art Institute in Los Angeles (where Philip Guston also studied briefly). Although he also attended art school at seventeen, he was not to make the final decision to devote himself to painting until 1941. The intervening years had been spent largely in the study of liberal arts and philosophy. He was led by his admiration of Delacroix's paintings to choose for his thesis subject at Harvard the esthetic theories expounded in Delacroix's journals. On the advice of his teachers, he therefore spent the year 1938–39 in France. Delacroix led to Baudelaire, Baudelaire to the theories of the French Symbolists and especially Mallarmé, and there followed a close study of the Parisian painters.

Shortly after Motherwell's return to the United States he moved to

New York. He discussed his first days there in a recent talk at the Yale University Art School:

> One of the great good fortunes I have had in my life, and there have been several, was that at a certain crucial moment in my life when I was in my mid-twenties and still hadn't really decided what I wanted to do, though in another way I'd always wanted to be a painter but through the circumstances of fate had never known a Modernist one . . . for better or worse, I don't know—at a certain moment through a contact with a friend who is now professor of music at Brandeis University I decided to go to New York . . . and study with Meyer Schapiro. In those days there was nothing like there is here, that if you were interested in contemporary art there was a place where you could go and be oriented. . . . The closest approach to it, though he is essentially a classical scholar, essentially devoted to the premises of art history and so on, in those days was Meyer Schapiro. And I went to New York and studied with Schapiro. Also by chance took a room near him and knew nobody in New York—nearly died of loneliness, at how hard and cold and overwhelming it seemed to me as a person from the Far West, which is with all its defects a somewhat more casual and open place.
>
> And sometimes at eleven o'clock in the night I would drag the latest picture I had been making on the side in the most amateurish way around to Schapiro. And one day in exasperation really, because I had then no conception of how busy people are in New York, he said, "It takes me two hours to tell you as best I can what any painter colleague could tell you in ten minutes. You really should know some artists." And I said, "Well, I agree . . . but I don't know any." [2]

As a child, Motherwell was haunted by the fear of death, perhaps partially because of his asthmatic attacks. He grew up during the Great Depression and, no matter what one's circumstances, one could not help being affected by it. The first foreign political event to engage his feelings was the Spanish Civil War, that perfect mirror of all that was confused, venal, and wrong in national and international politics and has remained so. For a slightly younger generation than Motherwell's, and by slightly I mean only by ten years or so, World War II was simply part of one's life. One went to war at seventeen or eighteen and that was what one did, perfectly simple, and one thought about it while one was about it, or you might say, in it. But Motherwell's ethical and moral considerations were already well formed by the time that war broke out, and for him the problems were quite different and also far more shattering psychologically.

[2] From a lecture given by Robert Motherwell at Yale University, New Haven, Hastings Hall, April 22, 1965.

It is no wonder then that when Meyer Schapiro introduced him to the European refugee artists who had fled here from the fall of France, he was strongly drawn to them, both as emblems of art and also as emblems of experience—an experience which no American artist save Gertrude Stein suffered as the French themselves did. Their insouciant survival in the face of disaster, partly through character, partly through belief in art, is one of the great legends, and it did not escape him. To recall the presence of these artists is indeed staggering. Motherwell's affinity for French Symbolist and Surrealist esthetics made him a quick liaison between the refugees and certain New York artists whom he scarcely knew at the time. The capitulation of France had brought about an intense Francophilism among all liberal intellectuals, especially those who felt strongly about the tragedy of the Spanish Civil War; and the fate of Great Britain was still in question. It was not too difficult to feel a strong identification, and of course these artists were already heroes of the modern artistic revolution; if some of them hadn't invented it, they had certainly aided, abetted, and extended it. In the artistic imagination these refugees represented everything valuable in modern civilization that was being threatened by physical extermination. It had never been more clear that a modern artist stands for civilization.

Modern artists ideologically, as the Jews racially, were the chosen enemies of the authoritarian states because their values were the most in opposition, so that one had a heightened sense, beyond the artistic, of seeing a Lipchitz or a Chagall walk free on the streets of New York. It is impossible for a society to be at war without each responsible element joining the endeavor, whether military, philosophical, or artistic, and whether consciously or not. The perspectives may be different, but the temper of the time is inexorable and demanding for all concerned. I think that it was the pressure of this temper and this time that forced from Abstract Expressionism its statement of values, which is, and probably shall remain, unique in the history of culture. While the other protesting artistic voices of the time were bound by figuration and overt symbolism, the Abstract Expressionists chose the open road of personal responsibility, naked nerve-ends, and possible hubris, and this separated them from the Surrealists, the Mexican School and the American Social Realists. Belief in their personal and ethical responses saved them from estheticism on the one hand and programmatic contortion on the other. Abstract Expressionism for the first time in American painting insisted upon an artistic identity. This, of course, is what made Abstract Expressionism so threatening to other contemporaneous tendencies then, and even now. The Abstract Expressionists decided, instead of imitating the

69

style of the European moderns, to do instead what they had done, to venture into the unknown, to give up looking at reproductions in *Verve* and *Cahiers d'Art* and to replace them with first-hand experimentation. This was the great anguish of the American artists. They had a sound theoretical, but no practical, knowledge of the suffering involved in being extreme; but they would learn. They shot off in every direction, risking everything. They were never afraid of having a serious idea, and the serious idea was never self-referential. Theirs was a struggle as ultimate as their painting. A struggle which, in the poet Edwin Denby's description in his reminiscence of the thirties, was against "the cliché about downtown painting in the depression—the accepted idea that everybody had doubts and imitated Picasso and talked politics. None of these features seemed to me remarkable at the time, and they don't now. Downtown everybody loved Picasso then, and why not. But what they painted made no sense as an imitation of him. For myself, something in his steady wide light reminded me then of the light in the streets and lofts we lived in. At that time Tchelitchew was the uptown master, and he had a flickering light."

During this period Motherwell veered between the opposite poles of the marvelous and the somber, if not morbid; from *Mallarmé's Swan,* imaged in subtle glacial beauty, to Pancho Villa's corpse, hanging bullet-riddled beside his live image, in which pink stains take on the aspect of not-yet-dried blood. Shortly before, in 1941, at the beginning of his painting career he had done three divergent pictures—*La belle méxicaine* (of his first wife, a Mexican actress), an imaginary landscape, *The Red Sun,* and the more purely conceptualized *The Little Spanish Prison.* The first owes a great deal to Picasso, the second to the Surrealist theory of automatism and especially to Masson, and the third is connected in my mind to the royal House of Orange, a modern version of Dutch clarity of tone allied with Spanish reserve and elegance. As a self-taught painter, Motherwell had many avenues open to him, and in beginning he did not close any of them off as possibilities.

Certain of the Abstract Expressionists seem to have burst into paint with an already emergent personal force from the very first works we know—one thinks particularly of Motherwell and of Barnett Newman. The variety from period to period in each of these artists encompasses a broadening of technical resources, as it does in Rothko also, and moves in a steadily rising power of emotional conviction. They have had a conviction, if not a style, from the beginning, more ethical than visual, which has left them free to include anything useful and has guided them away from the peripheral. As has Clyfford Still, for example, each has

chosen on several occasions to make moral statements in relation to his art, rather than esthetic ones.

This is, of course, a matter of temperament. The passions of others of their colleagues have led to far more abrupt and dramatic changes. Motherwell once remarked that an artist is known as much by what he will *not* permit as by what he includes in the painting. One would be hard put to aver whether Newman or Pollock, de Kooning or Rothko, was more *drastic* in his decision between the Dionysian and Apollonian modes of feeling, between seething impasto excitation and somber, subtly evoked grandeur.

Motherwell himself is very canny in his intuition of the relative values of these modes, as they apply to his expressive purposes, and of their limitations as abstract polarities for a sensibility which is modern both through intellectual act of faith and through natural inclination. The complexity of his modern esthetic is unified by certain basic preferences which govern every period of his work and are of an almost textbook simplicity: a painting is a sheer extension, not a window or a door; collage is as much about paper as about form; the impetus for a painting or drawing starts technically from the subconscious through automatism (or as he may say "doodling") and proceeds toward the subject which is the finished work.

These basic preferences have, however, a superstructure of great variety and subtlety. Motherwell first showed at Peggy Guggenheim's gallery Art of This Century in the early forties. The gallery chooses the artist, but the artist also chooses the gallery; for better or worse the gallery is the artist's public milieu, and in this case it was certainly for the better. Art of This Century was the headquarters in America for the militant Surrealists present in New York, and it also featured importantly Kandinsky, Mondrian, van Doesburg, Hélion, as well as Baziotes, Pollock, Hofmann, Rothko, and Still, among the Americans. Motherwell thus found himself in a milieu where simultaneous passions for the work of Mondrian, Max Ernst, de Chirico, Léger, and Joseph Cornell were enriching rather than confusing, joined together in time, place, and enthusiasm rather than compartmentalized and classified as they would have been in most art schools of the time, if taught at all. As the youngest member of this group, Motherwell already showed a stubborn individuality and purposefulness which were to remain characteristic through the years of experimentation with motif and symbol that lay ahead. In the preface to Motherwell's first exhibition, James Johnson Sweeney remarked on the artist's thinking ". . . directly in the materials of his art. With him, a picture grows, not in the head, but on the easel—from a collage,

1. *Iberia No. 2,* 1958. Oil on canvas, 47⅛″ × 80¼″.
Collection of the artist.

through a series of drawings, to an oil. A sensual interest in materials comes first." [3]

 This sensual interest in materials has led the artist away from the easel toward the small, decisively executed paper works of the *Lyric Suite* series and toward the monumental canvases, murals really, such as *Black on White, Africa,* and *Dublin in 1916, with Black and Tan.* Motherwell's admiration, which has continued throughout his career, for Matisse and Picasso, especially the "steady wide light" of which Edwin Denby wrote, have led him to a clarification of form and a toughness of drawing and color which would be impossible without the hard scutiny of this light. It is important to differentiate the light in different painters. The distinction is not always historical, nor is it always about source. It is in its actuality the most spiritual element, technical only in so far as it requires *means,* painterly means, to appear at all. It is the summation of an artist's conviction and an artist's reality, the most revealing statement of his identity, and its emergence appears through

[3] *New York. Art of This Century.* Robert Motherwell. New York, October–November 1944.

2. *Two Figures with Cerulean Blue Stripe,* 1960 (shown in progress) Oil on canvas, 84″ × 108″. Collection, Mr. Boris Leavitt, Hanover, Pennsylvania. Photo, Peter A. Juley and Son.

form, color, and painterly technique as a preconceptual quality rather than an effect (Fig. 1).

Motherwell once mentioned his experience as a child of being thrilled when a teacher drew in colored chalks a schema of the daily weather—an orange sun with yellow rays for fair weather, a purple ovoid cloud with blue strokes slanting through it for rain. Later, he remembered this experience, much as one remembers in adulthood having been pleased by Blake's *Songs of Innocence* as a child, only to find that they are masterpieces even to adults. Perhaps his belief in the communicative powers of schemata stems from this childhood experience. At any rate, his sensuality is involved as strongly with schemata as it is with texture or color. The sexual atmosphere of *Two Figures with Cerulean Blue Stripe* (Fig. 2), for example, has a specific tenderness and a poignancy which has nothing to do with "figure" painting or with handling; it is depen-

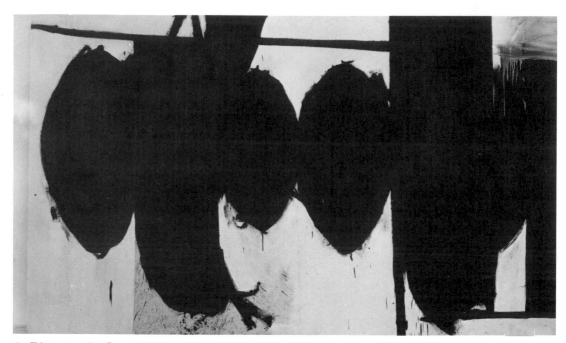

3. *Elegy to the Spanish Republic LXX,* 1961. Oil on canvas, 69″ × 114″.
Collection, The Metropolitan Museum of Art. Photo, Peter A. Juley and Son.

dent on the direct diagrammatic relation in a pictorial sense of the two
forms, where the blue stripe is a curtain drawn away from the intimacy
of the scene. It is the opposite of the Balthus painting of the gnome
drawing the curtain from the nude girl's window—where a Surrealist
voyeurism gives that painting piquancy, in the Motherwell a Courbet-
like health establishes a sense of both sexuality and repose.

Motherwell has also, through the same preoccupation with mate-
rial, been closely involved with "series" of paintings—in quotes because
the series sense is not necessarily that of subject matter but of sensitivity
to findings in the motif which yield further discoveries in the material.
The motif for the Elegies was discovered while he was decorating a page
of a poem by Harold Rosenberg in 1948. Almost immediately the motif
appears in a Spanish context, related to Lorca's poetry: *At Five in the
Afternoon, Granada;* and then shifts to the more specific associations
embodied in the "Elegies to the Spanish Republic" (Fig. 3). Sometimes
the motif itself dictates how to use the medium, where to drag it, splash it,
flatten an intervening area or flow it, in order to accomplish the presenta-
tion of the relationship of the images as a whole experience. The range

To the Glory of God

and

In Honor of

This gift has been made to

WESTMAR COLLEGE

LeMars, Iowa

by

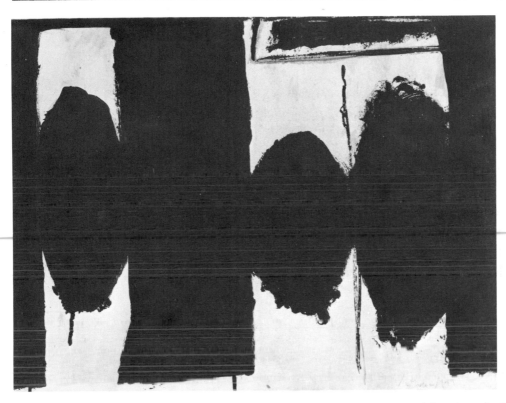

4. *At Five in the Afternoon,* 1949. Oil on composition board, 15″×20″.
Collection, Helen Frankenthaler. Photo, The Museum of Modern Art, New York.

of technical procedure between *Elegy LVII* with its almost expressionistic
drama to the strict, flat statement of *Elegy LV* reveals the fecundity
Motherwell has found in this motif and also indicates his ability to
bridge the gap between action painting and what Clement Greenberg has
called the "Post-Painterly Abstractionists." The latter *Elegy* in particu-
lar is also related to the transcendent exposure of the most recent works.
And always there is an absolute belief in the reality of the schema, exe-
cuted with such force that individual paintings of the series have been
variously interpreted as male verticals and female ovoids, as bulls' tails
and testicles hung side by side on the wall of the arena after the fight,
and as purist formal juxtapositions of rectangular and curvilinear forms.
As with the great recent painting *Africa,* the possibility of the schema's
arousing such a broad range of associations, depending on the emotional
vocabulary of the viewer, is a sign of its power to communicate human

passion in a truly abstract way, while never losing its specific identity as a pictorial statement. The exposure is one of sensibility, rather than of literal imagistic intent, and therefore engages the viewer in its meaning rather than declaring it.

This is an extreme divergence in aim from other Abstract Expressionists, excepting Rothko, Newman, and Gottlieb, while the compulsive urgency and crudity of Motherwell's drawing in paint separates him even from the latter artists. His work poises itself on the razor's edge of rawness and elegance, of brutality and refinement. With this pressure constantly on the hand, the arm, the eye, he must constantly reinvent the occasion for creation.

As devoted to exploration of motif as many of his contemporaries, he seems never to have to avoid repetition—indeed, he seems almost incapable of it. To recognize this quality in his temperament one need only compare the sensibilities involved in the *Femmes d'Algers* variations of Picasso and the "Blast" series of Gottlieb, for example, with Motherwell's series of "Elegies to the Spanish Republic." Without making a qualitative judgment, one may say that Picasso and Gottlieb are able to achieve their visual explorations within the hierarchy of an important and persuasively established pictorial structure; whereas Motherwell, from *At Five in the Afternoon* (1949, Fig. 4) on, is fighting an over-dominant and already clarified symbolic structure from which, through the years, he will wrench with astonishing energy some of the most powerful, self-exacerbating, and brutally ominous works of our time, and some of the most coldly disdainful ones as well (emptying of Self). In this sense, Motherwell creates the structure that opposes him, the domination of which he must overcome to remain an artist—it is not, as with Arshile Gorky, the marvelous finding of an apparently infinite number of family forms which may be juggled and tensed for more or less specific narrative purposes. In Motherwell the family of forms is a relatively small one and the plastic handling of them carries the burden of intention, whether passionate or subtle, whether buoyant or subdued; they are never used for narrative purposes, which is perhaps why Motherwell thinks of Gorky as a Surrealist artist, so different is their approach to form. Though both stemmed from the Surrealist theory of automatism, Gorky proceeded into the physiological "innards" of form and reference, while Motherwell dragged like a beast of pray his automatic findings into the neutral light of day and society.

Another important series, and one which both advances from previous preoccupations with gesture and proceeds toward later works with

calligraphic elements, such as *In Green and Ultramarine,* is the group of

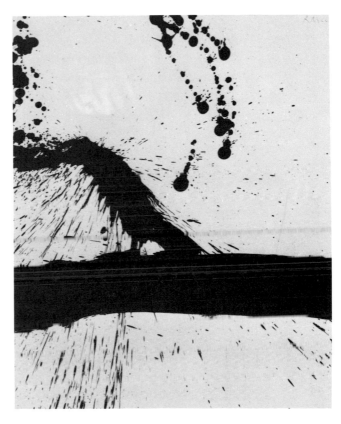

5. *Beside the Sea #34,*
1962.
Oil on rag paper, 28″ × 23″.
Collection of the artist.
Photo,
Peter A. Juley and Son.

works entitled "Beside the Sea" (Fig. 5). Here the motif of an abstract
wave breaking into the horizon and charging above it releases a marve-
lous arm-energy, and the characteristic Motherwell bands below, rather
than becoming indications of landscape, give the works an emblematic
drive. The sea is as much a metaphor as a throw of the dice is, or the
"Spanish Elegies."

Here too, as elsewhere, beginning with *Viva* and continuing through
the "Je t'aime" series, many of the works show Motherwell's literal use
of calligraphy as part of the compositional meaning of the painting. In
the case of the "Beside the Sea" pictures, his name is usually scrawled
through one of the dark bands at the bottom to lighten the tone of the
passage and to give variation and variety which balance the sharp force
of the "wave" above. In almost all of Motherwell's work the use of
the signature is compositional: an insistence on identity, to be sure, and
also an indication of the totality of the move away from easel painting—
few of the pictures are "signed" in the traditional sense, they are registered
by the artist as part of his life, in a matter-of-fact pictorial way, rather

77

coldly. Like de Kooning's, his calligraphy is so beautiful it would be a loss not to incorporate it in the picture.

Gertrude Stein gives us, in *The Autobiography of Alice B. Toklas,* some thoughts which are particularly applicable to the stance of much of Motherwell's work: "She always says that americans can understand spaniards. That they are the only two western nations that can realize abstraction. That in americans it expresses itself by disembodiedness, in literature and machinery, in Spain by ritual so abstract that it does not connect itself with anything but ritual. . . .

"Americans, so Gertrude Stein says, are like spaniards, they are abstract and cruel. They are not brutal they are cruel. They have no close contact with the earth such as most europeans have. Their materialism is not the materialism of existence, of possession, it is the materialism of action and abstraction." This observation, published in 1933, was prophetic of the whole new movement which was about to occur in American painting and sculpture, and which indeed had already been initiated by the three abstract painted metal heads of that year by David Smith, though she could not have known it. Her insight has also a relevance to the influence of contemporary Spanish artists, from Picasso and Gonzalez to Miró, on American and European artists, and particularly to the difference of application of this influence by the Americans, as opposed to, let us say, the French and the Dutch, and to the reverberations back on recent Spanish art. Her own inclination toward automatism was similar to that of many of the Abstract Expressionists: it fed and deepened a sense of structural necessity and of personal identity rather than obscuring the first and diffusing the latter, as automatism did so often with the Surrealists.

Though both Picasso and Gonzalez as Parisians have had a universal influence stylistically, their full, bold, and fresh spirit has been most importantly absorbed in American art, I think, by Motherwell and David Smith, respectively. An essential caustic Spanish rigor reached these Americans in their different media, a toughness, a tenacity and wrought-iron insistence which seem to have been imparted to no one else. For them, the example of identity was stronger than the style, as the idea of automatism was stronger than the practice. Instead of inspiration, the example of Picasso gave Motherwell control in his passion, as that of Gonzalez gave Smith elegance in his ambition, both necessary qualities for the accomplishment of basically unruly artistic ends. In contrast to the Surrealist painters, Motherwell does not yield to the subconscious, he is informed by it.

78 And this requires the daily confrontation of ethical as well as plastic

purposes. There can be no prefigured beauty to be achieved and no pre-determined set of symbolic referents which have not to be reexamined and tested for validity with each facing of the canvas. The constant testing and retesting of pictorial meaning, of the "charge" of imagery, has led to an enormous variety of content from work to work, and it has also led to the continual replenishment of the sources of that content, whether one calls it inspiration, inventiveness, restlessness, painterly ambition, whatever. The kind of artistic anxiety which seems to characterize Motherwell is the furthest from the kind that is debilitating. It has led him to find new skills in each period to serve the still mysterious demands of his consciousness.

Reuben Nakian

The career of Reuben Nakian has had dramatic ups and downs, advances, reversals, revaluations. His stylistic doubling-back and pushing-forward is not only exemplified by his development, but literally prefigured in his work: the slash-cut drawing into wet clay which ends as elegant, pastoral evocation of nymph and satyr; the harshly formed and rigidly armatured metal sheets which turn into erotic waves of Tarquinian lust and Lucretian submission, or autumnal leaves drifting toward a whimsical gravitational pull. His early belief in "democratic" mythic heroes as subject matter (Babe Ruth, Franklin Delano Roosevelt and his cabinet) was followed by his discovery of the pertinence of classical myth (Europa, Mars and Venus, Hecuba, Hellenic-Trojan tragedy in general). Nakian has created a remarkable oeuvre since the mid-forties through all these trials of temperament and of will; or perhaps, because of his harsh self-criticism and his insistence on continuing into the present the classical values of grandeur and nobility (in a nonacademic sense), one might say more accurately that a remarkable oeuvre has survived to poise itself against certain contemporary values that offend him. He said in 1954:

"I hate this age. We have no great people knocking at our doors and asking to come in and see what we're doing. It's very cold here. So you have to train yourself to ignore it. An artist should be alone, but he also should be with civilized people. . . . Art comes down to taste and aristocracy. Van Gogh, he was an aristocrat of the mind, of the taste. And that's why Picasso's so great. Anyone can draw or model. But you have to have taste to know exactly where to put a line or a color.[1]

Nakian was born in New York State, but like his friend Arshile Gorky he grew up in a combination of milieus—Armenian-familial and Brave-New-World-Dos Passos-USA social. Like most talented American artists of the period, he was at one and the same time the promising and the disadvantaged young man. Encouraged in his artistic interests by his parents, Nakian at the age of ten was studying drawing as other children study the piano, and like other talented children, he quickly developed considerable facility. The family was then living in New Jersey, but he felt the lure of New York City when he was sixteen, and his parents allowed him to follow it.

As a teenager in New York, Nakian took odd jobs of the sort which would now be on the periphery of the art world, but then were not so far from what the public regarded as its center. He worked as an office boy and in advertising agencies, did lettering for magazine covers, made line drawings for cigarette ads. He presumably thought of success in terms as various as James Montgomery Flagg, John Sloan, Maxfield Parrish, and Paul Manship. Thomas B. Hess gives an eloquent appraisal of the atmosphere of the art world during Nakian's teens and early twenties: ". . . It was a too-healthy, gamey, cosy American art-world that, in retrospect, seems terrifying and insane. Teddy Roosevelt was a culture hero, a muse for the non-alienated artist. A successful painter was a Success, a bully-boy of stag clubs who could sketch and tell jokes and hunt and be a sport, live a full strenuous life as an American—and die at the age of seventy with the understanding that his energy had been wasted on false ambitions; that his dedication had been to Others' standards and to their unreality; that whatever had been crucial for the individual had been thoughtlessly squandered in the convivial beery dream of the American Male."[2]

Nakian did not stay with the "beery dream" very long. His interest

[1] "10 Artist in the Margin." Edited by Belle Krasne. *Design Quarterly*, no. 30, pp. 14–15 ill., 1954.
[2] "Today's Artists: Nakian." Thomas B. Hess. *Portfolio & Art News Annual*, no. 4, pp. 84–99, 168–172 ill., 1961.

soon centered on a stylization of animal forms closely related to that of Gaston Lachaise, with whom he served his apprenticeship when he came to work in the studio of Paul Manship in 1916. Stylization was the order of the day, whether the archaistic stylization of a Manship, a kind of mock-heroic idealization of the proletariat, or a belated Art Nouveau stylization of human and animal forms, finding curves, swoops, and stabilized arabesques in breasts, thighs, torsos, a rabbit's ears, a bear's crouching back. The ultimate realization of this trend is found in Brancusi's *Seal* and *Fish,* in which the intensity of conception leads to an extreme abstraction of form; but the works of American sculptors of this period, excepting those of a few like Flannagan, Lachaise, and Zorach, now seem too easily formulated, too simply characterized, to command our admiration. Sculptural motion too, anecdotal and draped, was generally dependent upon stylization or was symbolized by clusters of dolphins or birds laboriously artifacted, until the slowly moving pedestals of Brancusi and the mobiles of Calder removed it from the illustrative to the actual. When sculptures were monumental, they were Neo-Classical-Realistic, or Federal-Commission style; when intimate, they often tended to look like centerpieces for a table of very indeterminate character and period.

In 1934 Nakian completed what seems from photographs (it has disappeared long since) an extraordinary and monstrous eight-foot figure of *Babe Ruth,* a definitely Zeitgeist-inspired work which was widely publicized. He had, however, preceded this in 1932–33 by portrait heads of some of his fellow artists and of collectors, and shortly after he began to follow an inclination toward the pursuit of more serious and climactic plastic exploration of subject matter. This is already hinted at in some of the portrait heads of the Roosevelt cabinet, and particularly in the one of Harry L. Hopkins. In this head, within the dual constraints of the brief time permitted for modeling in the Hopkins office and of a realism verging on that of the Social Realists, Nakian had already grasped a dreamy, idealistic tone which for the first time became overt and almost Roman. It seems now that in his early years Nakian's main problem was to make the dream overt rather than vulgar, and that all his researches for almost fifteen years after the Hopkins head were to culminate in the great resurgence of the terra-cotta "Europas" and the large plaster *Venus* of 1952 (now destroyed), with its hewn melancholy and innocence, which led to his present major period.

About 1935 Nakian began a drastic revision, singular and willful, of his artistic concepts. He had always sought a "land of his own" in art. Just as in the early twenties, while sharing a studio with Lachaise, he persisted in carving animal forms when Lachaise had already begun

working on monumental nudes, in the late thirties Nakian rejected the dominant School of Paris to cull earlier European art history for his right place. Little work of this period remains, but with the emergence of the terra-cottas toward the end of the forties we see that a great exploration had taken place. Greek mythology and its Roman interpretation assume an important role. As in a different stylistic context Gorky turned to the personal mythology of Xhorkom and Sochi, and many American painters adopted mythological titles for their emerging abstractions, Nakian's references began to range from Tanagra to Watteau, from Greek vase painting (transformed with modern energy and three-dimensional sharpness by the quick, deep incisions of his knife in the wet surface of the clay) to Rodin and Medardo Rosso, with their elaborately articulated surfaces and suggestive use of scale. Though he had met and become friendly with many artists who would later figure importantly in American art, the early terra-cottas seem most closely related to de Kooning's paintings of women begun in the late thirties, with their drastic cutting strokes of delineation, their massive definition, and the half-ominous, half-humorous ambiguity of their stance.

Nakian depicts his nymphs and Europas and Ledas and Hecubas as both goddesses and wantons, at once mischievous and melancholy, voluptuous yet serenely content in their artistic medium. In drawing with a wet brush, he de-idealizes the somewhat decadently erotic giantesses of Lachaise's pencil. He brings them closer to the fresh air of de Kooning's women and to the muscular virtuosity of what would come to be called Abstract Expressionism's "action," thus giving them an atmosphere of personality and whim, as real as fantasy, as illusory as believed myth (coy Leda, stately Minerva, proud Venus, mourning Hecuba, and so on). Similarly in sculpture, and contrary to the major direction of his contemporaries, Nakian employs the wet media, plaster and clay, to bring his work up to the immediacy and capriciousness of paint. In this development, handling becomes part of content while simultaneously commenting on it, and virtuosity lends candor to the general lubricity of subject. Through his intense reaction to media, Nakian brings the sense of touch to Lachaise's monumentalization of eroticism, and tenderness to de Kooning's confrontation of the female. When I say that Nakian's women seem content in their medium, I mean that they are caressed and enhanced, even ennobled by it. It is almost impossible to imagine an erotic or abductive act which Nakian's women (as, very differently, those of Fuseli's drawings) cannot encounter with equanimity and, on occasion, a hint of rather lofty encouragement. As myths, they have an abstract definition and security; as fantasies, they have an appetite for their own existence.

83

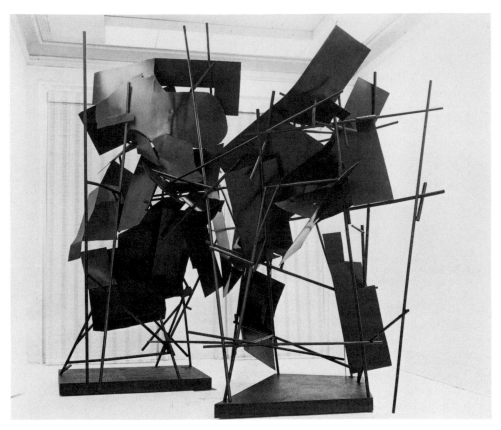

1. *The Rape of Lucrece,* 1955–58. Direct steel, 12′ 11″ long.
Collection, Joseph H. Hirshhorn Museum, Washington, D.C.
Photo, Thor Bostrom.

The work of the late forties and early fifties grows larger in scale, culminating in the painted steel sheets and rods of *The Rape of Lucrece* (Fig. 1), and it becomes apparent that eroticism is an important element in the success of Nakian's work in many ways. The sensuousness of his surfaces and forms, as of his themes, comes from this straightforward, exuberant, even classical eroticism, which is Mediterranean and completely involved with the world of the senses. As a motivating force, it establishes certain basic themes and attitudes, not only toward subject but also toward form, especially in the handling of surfaces and patinas and in the juxtaposition of abstract with figurative forms. For Nakian, eroticism is not only a means of insisting on the allusive content of the work, on the importance of subject in art, however abstract; but it also affirms, as in Lachaise and Gorky, the necessity of sensuality in art and, indeed, the essentially sensual nature of art. It is Nakian's eroticism, too, which

84

has prevented such monumental works as *The Rape of Lucrece, Mars and Venus,* the *Goddess with the Golden Thighs,* and the *Judgment of Paris* from straying into pomposity or vacuousness, and which has helped to maintain his characteristic buoyancy and spontaneity through the difficult realization of these huge works.

Nakian's work methods are a combination of Renaissance studio practice and the immediacy of Oriental calligraphers. In drawing, whether with brush or paper or with knife in wet clay or plaster, he demands completion by his action at the time of inspiration. A similar spontaneity is his goal in sculpture. The number of works destroyed because they didn't "work out," including several large sculptures, is staggering. This is not to say that the large pieces are not adjusted and worked upon, but that frequently Nakian goes too far in alteration and ruins them. To make possible this spontaneity, Nakian has had as permanent assistant the young sculptor Larry McCabe, who was his student at the Newark School of Fine and Industrial Arts in 1949. Since those days of solving the complicated problems of firing his early terra-cottas, McCabe has provided Nakian with the knowledge and help necessary to create a working situation in which wet clay or plaster is ready for the knife at the right moment, in which the technical problems of the internal-external structure of *The Rape of Lucrece* and the assembled monoliths of the *Goddess with the Golden Thighs* do not inhibit realization of the concept, and in which casting in bronze the subtly detailed and nuanced surfaces of a Hecuba takes on proper perspective to the major effort of creating the work itself, rather than becoming an impediment.

Having moved from Greenwich Village to Stamford, Connecticut, in 1948 Nakian set up a kiln and studio as best he could with his meager financial resources. Shortly after, in 1949, he began to exhibit terra-cottas at the Egan Gallery and continued to show there. Nakian contributed an odd and stimulating note to a stable of artists which has included such names as Willem de Kooning, Franz Kline, Giorgio Cavallon, Philip Guston, Jack Tworkov, Robert Rauschenberg, and others. Frequently, during exhibitions of other artists, an early Europa or Venus, and later the large *La Chambre à Coucher de l'Empereur,* could be seen through the office door posing like a dignified mascot. This latter work, done in white plaster in 1954 and cast in 1958, was Nakian's first major work of the new period; its baroque lavishness of form and texture persists in the later *Olympia* and relates closely to the recent *Birth of Venus.*

Seven years before *La Chambre à Coucher de l'Empereur* (Fig. 2), Nakian had completed a head of a woman, *Ecstasy.* It is a curious and, to me, rather unsatisfying work, harking back to the Art Nouveau style of illustrational erotic themes. This fulsome manner is capable of

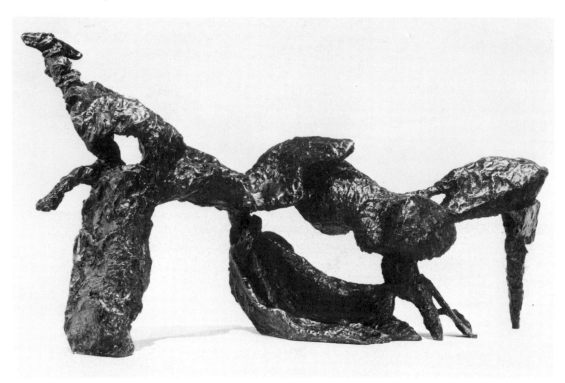

2. *La Chambre à Coucher de l'Empereur,* 1954. Bronze, 70″ long.
Courtesy, Charles Egan.

subtly cynical and ironic comment, but it does not at all benefit Nakian's blunt and innocent approach to the subject. Unlike the earlier *Head of Duchamp,* which for all its richness of handling has a strict attitude toward form, *Ecstasy* is notable for driving the formal implications of an emotion beyond the plastic boundaries justified by its meaning. It is a signal work in Nakian's oeuvre, in that it is the last overstatement within his mature period and reminds us of how excessive he could have become in terms of technique and modulation had not the ultimate seriousness of his intent become clear to him. An undeniable feat of virtuosity, the *Ecstasy* lacks the unity of impulse present in even the most physically dispersed of his later works, and its descent into decorativeness is the first sign of Nakian's awareness that the technical virtuosity he sought might be a trap. In contrast to the *Ecstasy's* reminiscence of Art Nouveau draperies (hair) and symbolized passion (smile), in the *Head of Duchamp* Nakian takes sculptural mass by thumb, finger, and forearm to extract from it a texture and space that lead directly toward the

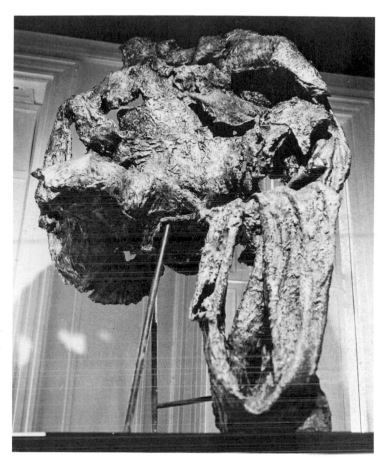

3. *Hecuba*, 1960–62.
Bronze, 7″ high.
Collection,
Cincinnati Museum of
Modern Art.

deeper content, the expanded open forms, and the dramatized surfaces of the important later works.

Nakian is unrepressed, un-neurotic, unabashed in his approach to sensuality, however tortuous his esthetic commitment, and whether his subject be death, bestiality, or Arcadian dalliance. This explicitness gives the "Nymph and Satyr" plaques a marvelous joy and ease, the "Europa" terra-cottas a voluptuous dignity, and the "Leda and the Swan" drawings an almost comic abandon. Unlike most sexually oriented images in modern art, from Rodin to Andy Warhol, one finds no guilt or masochism in a Nakian. It is outgoing and athletic even in its releases and defeats: the satyr, the bull, the swan, the goat are each circumvented or absorbed by the goddess of his choice in the most choice of circumstances, that of his own choosing, like the amorous "dying" of the Elizabethans or the metamorphoses of Ovid. Where tragedy is implied, as in *The Trojan Woman, Hecuba* (Fig. 3), and *Hiroshima*, it is the tragedy

of physical, not metaphysical, death: though metaphoric, the texture of the forms by insisting on physical dissolution keeps them from being intellectually distant or emotionally remote, no matter the degree of abstraction demanded by the subject or the obscurity of its expression. As Marianne Moore once remarked in a famous riposte, a poet should not be more clear than his natural reticence permits.

Nakian's literalness in thematic reference has led to remarkable abstract innovation. The huge curved black sheets which form the figures of Tarquin and Lucrece and delineate them with the freshness of a wash drawing are both supported and imprisoned by the rods. No longer merely armature, these rods are as intrinsic to *The Rape of Lucrece* as are the chamber, the bedposts, and the drapes in Shakespeare's poem. This liberation of armature and its new expressive role give *The Duchess of Alba* her chaise longue and *Mars and Venus* their fateful, spindling couch. Considered abstractly as forms, the black rods thrust away from gravity, lifting the black "leaves" aloft, and reenforce our sense of the masterful drawing, vertical supporting arabesque, contained in these works.

These three painted steel sculptures represent an original amalgamation of baroque indulgence with constructivist severity. Though the drawings and studies for them fit into the canon of Nakian's work with considerable stylistic unity, the three sculptures are a whole period in themselves—and the only one in which his later work relates at all clearly to other major American contemporaries, Calder on the one hand and David Smith on the other. Nakian's cut and bent black sheets remind one, however elliptically, of Calder's stabiles and of the motion of some of his heavy and stately mobiles; while Nakian's rods and interstices, like a supportive superstructure, recall the stainless steel "lines" with which, in several works of the late fifties, Smith connected and lifted aloft his brilliant flat planes. (In fact the word "soaring," used by Smith in one of his titles, could refer to several works of each of these artists, though they could hardly be related more closely than that.) Nakian later used the idea of curved metal sheets more literally in his sculpture for the Loeb Student Center at New York University, where the abstract aluminum leaves drift across the brick facade on the south side of Washington Square Park, on the site of one of his old studios.

Like many of the Abstract Expressionist painters, Nakian has always worked in series of motifs, and projected themes continue over long periods of time. The "Europa" series, begun in 1948, leads directly toward a more abstract development of this theme in the large bronze

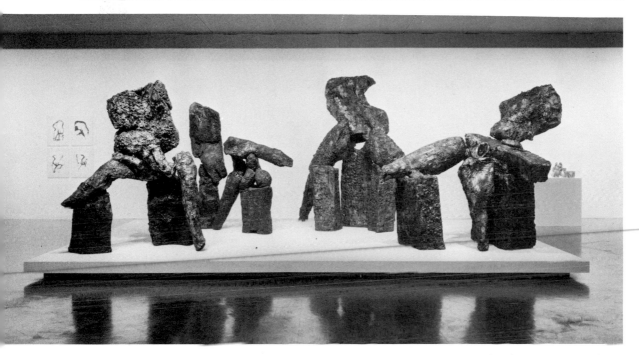

4. *Judgment of Paris,* 1964–65. Plaster. Collection, Egan Gallery.

Voyage to Crete of 1960–62, now in the New York State Theatre at Lincoln Center. A small *Paris* of the forties already prefigures the intent of the monumental group, the *Judgment of Paris* of 1963–66 (Figs. 4, 5), a project which has fascinated Nakian with obsessive regularity: the 1952 plaster *Venus,* a most remarkable work "in residence" for several seasons at the Egan Gallery, was later destroyed in Nakian's attempt to fuse the three goddesses and their judge into one large sculpture. With characteristic stubbornness he pursued this elusive theme into the sixties and created a group of four huge free-standing abstract figures (Paris, Venus, Juno, Minerva) poised in a fatalistic yet bawdy ritual, waiting for the apple of discord to be awarded and the Trojan War to start. The group is one of his masterpieces.

Not all the projects, even though diligently pursued, come to such complete realization. An exacting critic of his own work, though a generous one of others', Nakian is plagued by ambition and dissatisfaction. A superb recent *Maja,* like the earlier *Venus,* was destroyed in the attempt to make it even more beautiful. An earlier large sculpture, *Hecuba on the Burning Walls of Troy* (1954), a germinal work that foretold most of the technical innovations to follow, was destroyed and survives now in

89

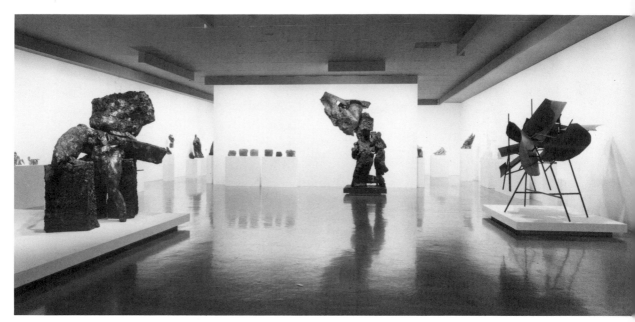

5. Installation view. Left to right: *Judgment of Paris: Juno,* 1964–65.
Plaster, 6′11″ high, Egan Gallery. *Hiroshima,* 1965–66. Bronze, 9′3¾″ high.
Collection, The Museum of Modern Art; Mrs. Simon Guggenheim Fund.
The Duchess of Alba, 1959. Welded steel, painted, 9′6″ long.
Los Angeles County Museum of Art.

spirit in the single-figure *Hecuba* of 1960–62—itself begun as a Hiroshima, which in the working out of the theme turned into a Hecuba. The "Hiroshima" theme has been attempted several times and either changed into another sculpture or destroyed; and Nakian still has pressing upon his consciousness projects for an *Homage to Arshile Gorky,* a *Death of Caesar,* a *Saint John* (with Herodias and Salome), as well as a longing to make fountains. This remarkable artist, now in his late sixties, has the energy of a young man and a confidence more sure for having been hard won, more certain for having included defeat, rejection, and triumph.

And the last word is the key one. Having withdrawn the *Birth of Venus* for further study and reworking after its initial showing in New York, Nakian has this year through his alterations produced a far greater sculpture than envisioned in his original conception, grand though that was. And in the recently completed *Hiroshima* (Fig. 5), he has created a tragic and taciturn plastic expression capable of dealing in a work of art with our guilt over this horrifying event. The expectable Hellenic catharsis, the one Hellenic idea that Nakian seems never to

90

have espoused with any degree of enthusiasm, disappears in the morbid beauty of the work's realization; while the erotic works remain libidinous and arousing for all their esthetic grace. The sculptural message of the late, mythologically inspired works, particularly *The Trojan Woman* and *Hecuba*, has been that all flesh is as grass, vulnerable, destructible; and *Hiroshima* brings this out very forcefully. It is philistine to decry as childish the content of Pop and junk art, as Nakian is apt to do in conversation, unless you, like Nakian, have achieved a relationship with physical truth that is both stoic and sybaritic, wherein the dead live and the living wait in a kind of despairing sensual delight.

How to Proceed in the Arts

with Larry Rivers

A Detailed Study of the Creative Act

1. Empty yourself of everything.

2. Think of faraway things.

3. It is 12:00. Pick up the adult and throw it out of bed. Work should be done at your leisure, you know, only when there is nothing else to do. If anyone is in bed with you, they should be told to leave. You cannot work with someone there.

4. If you're the type of person who thinks in words—paint!

5. Think of a big color—who cares if people call you Rothko. Release your childhood. Release it.

6. Do you hear them say painting is action? We say painting is the timid appraisal of yourself by lions.

7. They say your walls should look no different than your work, but that is only a feeble prediction of the future. We know the ego is the true maker of history, and if it isn't, it should be no concern of yours.

8. They say painting is action. We say remember your enemies and nurse the smallest insult. Introduce yourself as Delacroix. When you leave,

Poem-Painting by Norman
Bluhm and Frank O'Hara, 1960.
Photo, John D. Schiff.

give them your wet crayons. Be ready to admit that jealousy moves you more than art. They say action is painting. Well, it isn't, and we all know Expressionism has moved to the suburbs.

9. If you are interested in schools, choose a school that is interested in you. Piero Della Francesca agrees with us when he says, "Schools are for fools." We are too embarrassed to decide on the proper approach. However, this much we have observed: good or bad schools are insurance companies. Enter their offices and you are certain of a position. No matter how we despise them, the Pre-Raphaelites are here to stay.

10. Don't just paint. Be a successful all-around man like Baudelaire.

11. Remember to despise your teachers, or for that matter anyone who tells you anything straight from the shoulder. This is very important. For instance, by now you should have decided we are a complete waste of time, Easterners, Communists, and Jews. This will help you with your life, and we say "life before art." All other positions have drowned

Somewhere outside yourself
there is a small silent cry
waiting
to become part of the
universal attention
now that we
are almost at war and have
again become individuals

we are not on vacation any more
or at the ballet
we're going to die
"sela morladite"

Poem-Painting by Norman Bluhm and Frank O'Hara, 1960.
Photo, John D. Schiff.

in the boring swamp of dedication. No one paints because they choose to.

12. If there is no older painter you admire, paint twice as much yourself and soon you will be him.

13. Youth wants to burn the museums. We are in them—now what? Better destroy the odors of the zoo. How can we paint the elephants and hippopotomuses? Embrace the Bourgeoisie. One hundred years of grinding our teeth have made us tired. How are we to fill the large empty canvas at the end of the large empty loft? You do have a loft, don't you, man?

14. Is it the beauty of the ugly that haunts the young painter? Does formality encompass the roaring citadels of the imagination? Aren't we sick of sincerity? We tell you, stitch and draw—fornicate and hate it. We're telling you to begin. Begin! Begin anywhere. Perhaps somewhere in the throat of your loud ass hole of a mother? O.K.? How about some red-orange globs mashed into your teacher's daily and

unbearable condescension. Try something that pricks the air out of a few popular semantic balloons; groping, essence, pure painting, flat, catalyst, crumb, and how do you feel about titles like "Innscape," "Norway Nights and Suburbs," "No. 188, 1959," "Hey Mama Baby," "Mondula," or "Still Life with Nose"? Even if it is a small painting, say six feet by nine feet, it is a start. If it is only as big as a postage stamp, call it a collage—but begin.

15. In attempting a black painting, know that truth is beauty, but shit is shit.

16. In attempting a figure painting, consider that no amount of distortion will make a painting seem more relaxed. Others must be convinced before we even recognize ourselves. At the beginning, identity is a dream. At the end, it is a nightmare.

17. Don't be nervous. All we painters hate women; unless we hate men.

18. Hate animals. Painting is through with them.

19. When involved with abstractions, refrain, as much as possible, from personal symbolism, unless your point is gossip . . . Everyone knows size counts.

20. When asked about the old masters, be sure to include your theories of culture change, and how the existence of a work of art is only a small part of man's imagination. The Greeks colored their statues, the Spaniards slaughtered their bulls, the Germans invented Hasenpfeffer. We dream, and act impatient hoping for fame without labor, admiration without a contract, sex *with* an erection. The Nigerians are terrible Negro haters.

Working on the Picture

The Creative Act As It Should Flow Along

1. You now have a picture. The loft is quiet. You've been tired of reality for months—that is, reality as far as painting goes. The New York School is a fact. Maybe this painting will begin a school in another city. Have you started—now a lot of completely UNRELATED green—yes, that's it. We must make sure no one accuses you of that easy one-to-one relationship with the objects and artifacts of the culture. You are culture changing, and changing culture—so you see the intoxicating mastery of the situation. In a certain way, you are precisely that Renaissance painter whom you least admire. You are, after all, modern enough for this, aren't you? Don't be sentimental. Either go on with your painting or leave it alone. It is too late to make a collage out of it. Don't be ashamed if you have no more ideas; it just means the painting is over.

Skin with O'Hara Poem by Jasper Johns and Frank O'Hara, 1963.
Photo, Rudolph Burckhardt.

2. Colors appear. The sounds of everyday life, like a tomato being sliced, move into the large area of the white cloth. Remember, no cameras are recording. The choice you make stands before the tribunals of the city. Either it affects man or infects him. Why are you working? No one cares. No one will. But Michelangelo has just turned over in his grave. His head is furrowed and you, like those dopey Florentines, accuse him of being homosexual. He begins to turn back, but not before you find yourself at his toes, begging for the cheese in between.

3. At this point go out and have a hot pastrami sandwich with a side order of beans and a bottle of beer. Grope the waitress, or, if you are so inclined, the waiter. Now return to your canvas—refreshed and invigorated.

Stones by Larry Rivers and Frank O'Hara, 1958.
Photo, Herbert Matter.

4. Michelangelo??? Who likes cheese anyway? Call a friend on the phone. Never pick up your phone until four rings have passed. Speak heavily about your latest failure. (Oh, by the way is this depressing you? Well, each generation has its problems.) Act as if there is continuity in your work, but if there isn't, it is because that position is truly greater. Point out your relationship to Picasso who paints a Cubist painting in the morning, after lunch makes a Da Vinci drawing and before cocktails a *Sturm und Drang* canvas out of the Bone Surreal oeuvre. His ego is the point of continuity.

5. Do you feel that you are busy enough? Truly busy. If you have had time to think, this will not be a good painting. Try reversing all the relationships. This will tend to make holes where there were

hills. At least that will be amusing, and amusement *is* the dawn of Genius.

6. If it is the middle of the day, however, discard the use of umber as a substitute for Prussian blue. Imitation is the initial affirmation of a loving soul, and wasn't James Joyce indebted to Ibsen, and didn't we know it from his words "at it again, eh Ib."

7. Later on, imitate yourself. After all, who do you love best? Don't be afraid of getting stuck in a style. The very word style has a certain snob value, and we must remember whom we artists are dealing with.

8. Refine your experience. Now try to recall the last idea that interested you. Love produces nothing but pain, and tends to dissipate your more important feelings. Work out of a green paint can. Publicly admit democracy. Privately steal everyone's robes.

9. If you are afraid you have a tour de force on your hands, be careful not to lean over backwards. It is sometimes better to appear strong than to be strong. However, don't forget the heart either. . . . Perhaps we mislead you. . . . Forget the heart. To be serious means to include all. If you can't bear this you have a chance of becoming a painter.

10. Whatever happens, don't enjoy yourself. If you do, all that has been wisely put here has been an absolute waste. The very nature of art, as opposed to life, is that in the former (art), one has to be a veritable mask of suffering, while in the latter (life), only white teeth must pervade the entire scene. We *cry* in art. We *sing* with life.

Cavallon Paints a Picture

One of the interesting aspects of the painters of the New York School is their use of black and white as colors. This has occurred in few other periods of art, and the new emphasis has as many individual interpretations as there are ways of discussing the white-as-all-color, black-as-absence-of-color (and vice versa) dichotomy and its psychological ambivalences. Insofar as we are thinking of painting, its interpretation depends on use, and scientific inquiry is merely piquant. Techniques of painting have been explored so thoroughly in recent years that their usages now seem to have evolved almost symbolic weights and meanings, not as absolutes, but as stances. In this situation, the black in a Franz Kline seems to imply a value beyond formal value, as it does in the late "black" Goyas, the emergence of passion into the light of experience. In a similar way the totally white paintings in Robert Rauschenberg's second show seemed to represent a gesture opposed to the action of painting the canvas, and indeed he has never been, or become, an "Action Painter" in the sense that Malevich never was one. The use of white in Giorgio Cavallon's paintings of recent years has also

a strong significance, bringing the light in the other colors to culmination in the completed painting, like the conclusion of a Platonic dialogue between the painter and the painting where all the "arguments" fall into place in a final illumination.

Giorgio Cavallon was born in Sorio, near Venice, in 1904. He came to the U.S. at the age of sixteen and has lived here, first in Springfield (Mass.) then in New York, ever since, except for 1930–33, spent in Italy. Before this trip he had studied at the National Academy of Design and with Charles Hawthorne in Provincetown, as well as won a Tiffany Scholarship (1929).

When he returned to the U.S., he studied with Hans Hofmann for a while and worked on the Art Project of the W.P.A.

Of this time Cavallon, who is friendly and reserved, speaks seldom but very definitely, says that he did not know what made an abstract painting an abstraction. Unlike many of his fellow-artists in that period, he did not feel that Picasso was any help with this problem; Picasso did not seem pertinent to his own work. In this Cavallon's attitude was the opposite, of course, to that of his friend Arshile Gorky. There is a clue to what he did find pertinent in a Cézannesque sketch for the portrait of a girl (1937) still in his possession. And one can understand what he felt in turning to Cézanne, that master of the deepest and most arduous and painful self-imposed problems, instead of to Picasso, who seems even now never to have felt anything a problem but to have simply faced and given a face to all that occurred to his imagination, thus offering innumerable problems to others, should they wish to impose them upon themselves. There seems to be evidence of an interest in Jean Hélion's abstractions in an untitled painting (1938–39) which was shown in the Poindexter Gallery's exhibition, "The 30s," last year. De Kooning's small abstractions of this same period reveal an interest in Hélion, too, and there is something in this Cavallon relating to de Kooning and to Gorky. But each artist saw a totally different aspect of form in their French colleague: Cavallon solid and formal, resembling an abstract still-life seen from above; de Kooning suggesting an aerial space (there seems to be a balloon in one painting of this period) through which similarly *substantial* abstract forms move through simultaneous light-years. Cavallon had, in effect, made the still-life into a wall with imbedded forms. The forms would disappear soon, but the wall remains. For in the next few years the spirit of Mondrian appears. Not the Mondrian of the pier series, a horizontal image which you seem to be looking down on, but the later Mondrian of vertical erectness, with its air and light. Light is all-important in a Cavallon and in this connection one notices in the paintings of the late forties and early

fifties, and in the Mondrians to which they seem to be related, the source of light is the image on the canvas toward which the viewer looks for illumination, whereas in the pier series the viewer is nearer the source of light himself which, as he looks, falls upon the image.

This Neo-Plastic period of Cavallon should not be neglected, for at that time he was a most subtle and sensitive practitioner of the style. Unlike most of the American painters involved in this movement, Cavallon went unerringly to the one quality in Mondrian which set him apart from De Stijl or any other school, the quality of the surface. This is the skin of the scaffold, the light from the buildings, the air above Trafalgar Square, the sound of the Boogie-Woogie, in Mondrian; and however reticently one may confess the meaning of his universal images to one's own eye, it is the extra, therefore the essential quality which sets Mondrian apart, as it does Malevich, from the broad and tedious purity of much modernism. For most painters of the Neo-Plastic persuasion, the works of these artists has spelled exclusivity, the influence has been toward what should *not* happen; for Cavallon, it pointed the way to a new richness: it had not to do with specific form, but with conviction finally stripped of restraint. Instead of the look or format, Cavallon found in Mondrian an execution which he could develop and make his own, and as the master himself said of this element of painting: "let us note that it must contribute to a revelation of the subjective and objective factors in mutual balance. Guided by intuition, it is possible to attain this end. The execution is of the greatest importance in the work of art; it is through this, in large part, that intuition manifests itself and creates the essence of the work."

Without Mondrian's interest in metaphysics, Cavallon brought this element more and more to the fore. As his sensitivity to tactile quality increasingly dominates his work, the formal interest changes. It is the preference for mass as opposed to line, though it always begins with linear definition, as we see in the first stage of the present painting (Fig. 1). Here the charcoal first violates the white of the surface and presents the subjective state concentrating on the void. This is not an extraordinary predicament; some painters choose to coat the surface with an energizing color, others fling an initial statement into the abyss to violate the silence. With Cavallon the initial gesture is classical: drawing. It is not necessarily the basis for the composition, but a start with and against which to work. It may operate as a plot of color emphasis, or it may indicate the psychological area in which events are about to take place, or a formal preference from a previous painting which he will presently violate.

Working instinctively from this point on, he places color somewhere

1. Initial drawing
for #95, 1958.
Photo,
Rudolph Burckhardt.

*1. His painting begins, in the classical manner,
with a charcoal drawing.*

on the plane in relation to the white surface and the black lines. Addition by addition, the color-masses erect a wall of space upon which to operate and the black lines totally disappear. The range of this color is quite extreme compared to that of the finished painting. Differentiations of value are created and absorbed. There seems to be no prejudice exercised. Cavallon observes a great deal and to see him sitting before the painting and it staring back at him, "the subjective and objective factors," reminds one vividly of the Socratic dialogue. By the time the painting arrived at this stage (Fig. 2) it was a panorama of juxtaposed masses with a strong dramatic center of black, still retaining a drawing-in-paint emphasis in certain areas. For all the vividness of articulation, this is the night of the painting, in which each formal element is in combat.

102 The painter Mercedes Matter once said at an exhibition of Cavallon at the Egan Gallery that no one who did not see a whole show of his

2. Stage IV of #95, 1958.
Photo,
Rudolph Burckhardt.

*2. Then, colors move slowly, from the palette table to
the canvas; the range of hues is at first bright,
and a "drawing in paint emphasis" is retained. As the
painting progresses, hues increase in intensity; there is
a panorama of juxtaposed masses with a strong dramatic
center of black. Then whites are added, the whole canvas
becoming illumined from within.*

work could understand the peculiar fascination he exerts for painters. The warmth of luminosity and the strength of the illumination are particularly strong then. They come from individual paintings, but are dramatized by surrounding ones and the contemporary audience is so used to being smashed over the head by "statements" that they tend to ignore anything less than a torn T-shirt or a waistcoat swimming with live salmon. (What she said is equally true of another contemporary, Mark Rothko.)

There *is* that peculiar quality to an exhibition of Cavallon's work: it

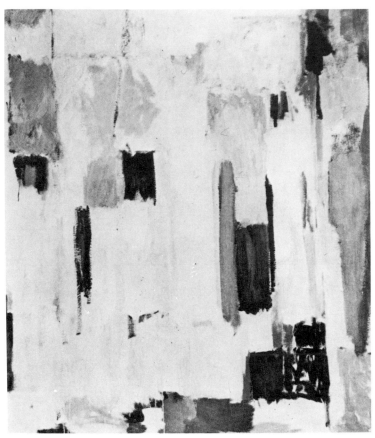

3. *#95,* 1958.
Oil on canvas,
50″ high. Private collection.
Photo, eeva-inkeri.

*3. In the final adjustments, both the whites
and bright colors are modified
to achieve an extraordinary resonance.*

resembles a town in southern Italy the walls of which have absorbed the sunlight for centuries and even on a cloudy or raining day give off the intense light of what they have absorbed. What Cavallon's paintings have absorbed is the tender and lofty philosophy of his innermost thoughts. A studied and intense painter, the drama of meaning occurs in the studio rather than on a canvas stage. I do not say this as a preferential remark, but as a cue to his particular quality, breathing, articulate and final.

This final luminosity is achieved by white. There is something Spanish about Cavallon's work, too. How happy Velasquez must have been that there was lace. He would have done it anyway. As the painting progresses, Cavallon adds whites, whites with a past, whites with purity, whites with their differentiations (Figs. 2, 3). At a certain point the whole

painting seems to be becoming white. But you can't have just light, which would be a position taken *toward* painting, rather than *in* painting toward experience. Within the dialogue of the painter and the painting there was still more to be said and decided upon before the conclusion. There is a pertinent passage in Pasternak: "The reason for his revision and rewriting was his search for strength and exactness of expression but they also followed the promptings of an inward reticence . . . As a result his feeling, pulsing and warm, was gradually eliminated from his poems, and romantic morbidity yielded to a broad and serene vision that lifted the particular to the level of the universal and familiar. He was not deliberately striving for such a goal, but this broad vision came of its own accord . . ." This, it seems to me, applies to Cavallon and is, in fact, the secret of much abstract art of the highest value.

As Cavallon continued to work, certain areas of the painting (the upper left, the lower right and some signal masses right of center) remained the same while much changed around them. The delicate adjustment of each to each proceeded toward unification by removing the drama of the dark passage in the center. Now the other areas, in response to the white which was itself illumined by the underpainting, began to glow with their true resonance. This procedure, though conducted entirely through addition, seemed finally to have called forth the intrinsic values of the work as a whole, not heroizing the white, but much as sunlight in certain climates and on certain days seems to radiate from one's surroundings, not fall from the air.

It is difficult to convey the power and conviction of Cavallon's work, its precise, yet airy and sensual, logic. One of the least expressionistic and most abstract painters of the New York School, his method is private and mute, including no signs of calligraphic voices. The finished painting is, however, completely articulate in the noninsistent way that true conviction is.

And white, by its preponderance and variety in his recent work, assumes the role of an acute intelligence, correcting, uniting, discovering the universal meaning of all the particular perceptions which have gone before, making this meaning suddenly familiar.

Larry Rivers:
"Why I Paint As I Do"

Larry Rivers lives in a house in Greenwich Village on a street crowded with bars and coffeehouses behind the New York University Law School building. Formerly inhabited by a scene designer, the studio is two stories high with walls of brick, whitewashed many years ago and now covered with the city's patina of warm gray. In the daytime the light pours in from three skylights, but at night it is a vast, dim place, lit by seven naked light bulbs hanging high up near the ceiling. At night the studio looks very much like the set for Samuel Beckett's *Endgame;* it's hard to believe you can find out anything about the outside world without using a ladder; the windows are way up.

Part of the house is divided into two floors, duplex style, the upper floor with a little balcony overlooking the studio. On these two semifloors the artist lives with his youngest son, Steven, thirteen years old. (His older son, a painter too, lives not far away in his own cold-water studio.) The other member of the Rivers household is a friendly, frantic shepherd dog named Amy who is perpetually hungry and lunges up and down the stairs in a delirium of affection for all comers.

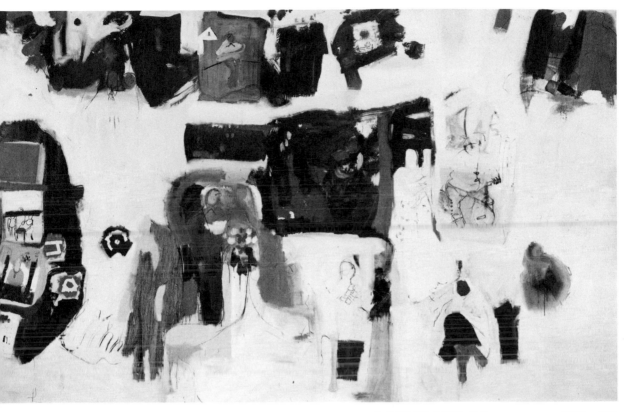

1. ME II, 1958. Oil on canvas, 8′9″ × 10′.
Collection of the artist. Photo, Rudolph Burckhardt.

On one of the studio's huge walls is stapled a 10 by 15 foot canvas, in preparation for the start of the artist's projected new work *ME* (Fig. 1). On the opposite wall a female figure in welded steel has been attached several feet off the floor—the sculpture which appears in two of his paintings, *Second Avenue* and *Second Avenue with THE* (Fig. 2). It was made in 1957 in Southampton, Long Island, where the Riverses lived for four years. Another wall has the huge *Journey* of 1956, a painting which looks small in the space of the studio; lurking under a nearby potted plant is a plaster commercial figure of Psyche or Aphrodite which Rivers rescued from a night club; she is holding an orange light bulb in her uplifted hand and Rivers uses her as a night light.

I have known Larry Rivers since 1950, when he had just returned from Europe. It was at a cocktail party we met, as one always meets people in New York, and waving at the crowd he said, "After all it's life

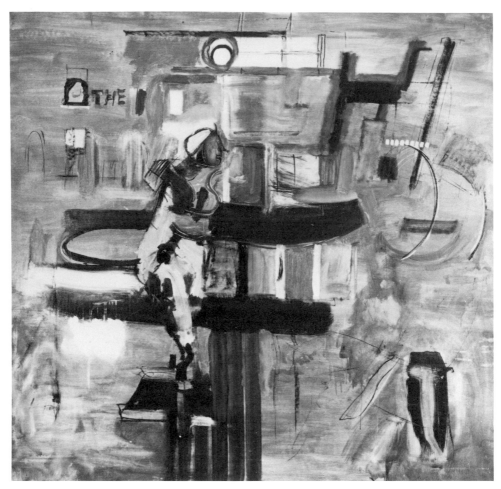

2. *Second Avenue with THE,* 1958. Oil on canvas,
72¾" × 82¾". Collection, Mr. and Mrs. Patrick B. McGinnis.

we're interested in, not art." A couple of weeks later when I visited his studio for the first time, with its big splashy canvases and the beginnings of full-scale female nudes in plaster hanging from pipe-and-flange armatures, he said with no air of contradiction or remembrance, "After all it's *art* we're interested in, not life." His main interest was obviously in the immediate situation. And so it seems to have remained.

He talks clearly and vividly, and answers questions about his profession with an intensity which indicates he does a lot of thinking about art, particularly contemporary art and his position relative to it. The interview began, however, with a question which started Rivers talking about his youth.

RIVERS: I am a native New Yorker. I grew up in the streets of what was much less inhabited in those days—the Bronx. From about the age of six to ten I went to the zoo four or five times a week. I loved the big cats more than any other animal. I used to trail behind men until they dropped cigarettes and then I'd pick them up and smoke them. The only things in our house resembling art were a cheap tapestry, a cross between a Fragonard and a Minsky popular in many dining rooms in the twenties, and a five-and-ten-cent store 8 by 10 reproduction of a Spanish *señorita* holding a flower just above an exposed breast, a painting which, to make matters worse, followed us from one apartment to another. Mind you, when I took my mother to her first exhibition of paintings—she having had such a profound dining room education in art—she told me which were good paintings and which were bad in a *very* strong voice. But if I've inherited natural bad taste I'd praise my parents for passing on to me their strength, their natural physical endurance and animal concentration. So much in the making of art is energy. Not just the manipulation of the arm or fingers, but the physical insistence of the mind to keep on making decisions—in spite of continuous physical and mental disruption. Just how much mention of an arm in charcoal will be *too* much: *what* is too much; do I really want it all? Was the red paint on the brush meant for the left-hand corner—when I've gone back to look at it after receiving a call from some Detroit doctor whose wife wants to come around and buy a painting, and who never eventually turns up. Again, do I like this all-over-completely-raw-umber painting with only a four-inch gray slab that de Kooning says looks mysterious and interesting but that took me only twelve and a half minutes to paint—five minutes before a phone call and seven and a half after, plus one hour in the stretching of the canvas. Et cetera, et cetera.

INTERVIEWER: It would seem to be agony. But being an artist wasn't what you wanted at the beginning, was it?

RIVERS: In the early days I really wanted to be a great jazz musician and my heroes then were Charlie Parker and Lester Young. A few years later, having had a couple of distressing love affairs, lived in severe financial doubt, I worked as a delivery boy for an art-supply house and felt here that I had discovered the delights of art. My heroes were Picasso and Gonzales. Then I became exposed to modern painting and it was exciting enough to make me enter Hans Hofmann's classes to learn painting. But I kept up with the music. In 1947 I went to Provincetown and spent the days in Hofmann's school there and played sax at the Sea Dragon every night of the summer. In the

winter I went to Hofmann's school in New York and played almost every night. In fact, until recently my idea of an evening was to take my sax and go to a Negro dance hall and blow the entire night, and drink, lots. But gradually the impulse to be a great painter became stronger. Music became relegated to the role of what others find in socializing for an evening. And then finally there was no need for heroes—a Parker or a Picasso. This is because when you're young you want to *be* someone. When you're older you want to *do* something. Now that I've been caught up in the activity of art for a few years, I just want to do it, I just want to keep on painting; there's nobody I want to be.

INTERVIEWER: What did you learn at Hans Hofmann's school?

RIVERS: Aside from his theories of art, like "push and pull," he made art glamourous by including in the same sentence with the names Michelangelo, Rubens, Courbet, and Matisse, the name *Rivers*—and his own, of course. It wasn't that you were a Michelangelo or a Matisse, but that you faced somewhat similar problems. What he really did by talking this way was to inspire you to work. He had his finger on the most important thing in an artist's life, which is the conviction that art has an existence and a glamourous one at that. He puts you on the path with the desire to go somewhere. What you find along the way is your own problem. *My* problem back then in 1947 was that when I started drawing in the presence of a nude female model, all that found its way onto my pages were three peculiar rectangles. At the end of a year I became frantic to draw the figure, and in a way that is no more advanced than Corot. If I didn't do this, I'd never be able to convince myself of my genius. To want to draw like Corot, or, for that matter, any master, was more related to *identification* than to the creation of an original work. It was important to me to solidify my position, to be able to say, "Yes, don't worry, you are really an artist."

INTERVIEWER: You must have been successful. Your first show was in '49, wasn't it, two years after you started at Hofmann's school?

RIVERS: Yes, in the Jane Street Gallery, then on Madison Avenue. The next year the critics Clement Greenberg and Meyer Schapiro picked me to be one of the artists in a "New Talent" show for the Kootz Gallery. This set me up enormously. At this time I was also writing a lot of poetry. I had lots of energy in those days and felt that poetry was a part of life that music and art didn't cover. I think I wasn't so interested in poetry as in saying something about my

own life, whereas now I am more interested in painting than in anything it can say about my life.

INTERVIEWER: You spent a year in Europe—in 1950. What was its effect?

RIVERS: I wrote lots of poetry in the daytime, went to language school, and looked at a lot of things all over the place but didn't have any idea what they meant.

INTERVIEWER: But your work did change after you got back?

RIVERS: That was mostly because I hadn't painted for such a long time. And I did get rather bored with Bonnard after having admired him and painted like him for so long. Then along came Soutine. But I decided that the racing-elbow stroke and the big arc motion of the hand had to go. It had become the language of the mediocre painter, through no fault of those who invented it. I'd heard that Prokofiev wrote his Classical Symphony in the middle of his career in an attempt to create something absolutely conditioned by another time. Well, I had a complete reversal. I tried to do the same thing. Géricault painted a male nude perhaps two feet tall. I painted one eight feet high. I felt competitive and wanted to prove myself as good, if not better, on their own terms. I wanted to paint flesh as pink sienna and gorgeous as anything done. I think I fell somewhere about a mile from what I wanted and tried to make up for the failure by size and number. You must love to imitate, but it is not enough.

INTERVIEWER: What do you think of those paintings of yours now?

RIVERS: Those figure paintings, as good as some may think them, are an early stage of my development. As I look at them now, if I get to see them, I forget how I did them. I remember the situation in which they were painted; one person who posed for me is dead. I don't even know how to mix those colors again. I don't regret painting them, but I'm not particularly proud of them.

INTERVIEWER: The famous *George Washington Crossing the Delaware* (Fig. 3) was painted soon after your return from Europe, wasn't it? Was it influenced in any way by what was going on in New York art circles?

RIVERS: Luckily for me I didn't give a crap about what was going on at the time in New York painting, which was obviously interested in chopping down other forests. In fact, I was energetic and egomaniacal and what is even more: important, cocky, and angry enough to want to do something no one in the New York art world could

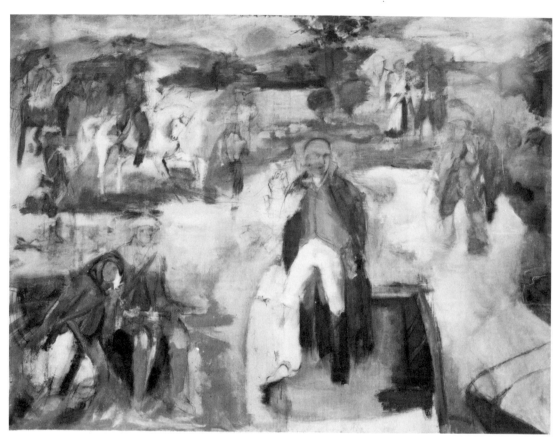

3. *Washington Crossing the Delaware*, 1953. Oil on canvas, 6′11⅝″ × 9′ × 3⅝″.
Collection, The Museum of Modern Art, New York; given anonymously.

doubt was *disgusting, dead,* and *absurd.* So, what could be dopier than a painting dedicated to a national cliché—Washington Crossing the Delaware. The last painting that dealt with George and the rebels is hanging in the Met and was painted by a coarse German nineteenth-century academician who really loved Napoleon more than anyone and thought crossing a river on a late December afternoon was just another excuse for a general to assume a heroic, slightly tragic pose. He practically put you in the rowboat with George. What could have inspired him I'll never know. What *I* saw in the crossing was quite different. I saw the moment as nerve-racking and uncomfortable. I couldn't picture anyone getting into a chilly river around Christmas time with anything resembling hand-on-chest heroics.

INTERVIEWER: What was the reaction when George was shown?

RIVERS: About the same reaction as when the Dadaists introduced a toilet seat as a piece of sculpture in a Dada show in Zurich. Except that the public wasn't upset—the *painters* were. One painter, Gandy Brodie, who was quite forceful, called me a phony. In the bar where I can usually be found, a lot of painters laughed. One female painter, because of the style of the painting, dubbed it "Pascin Crossing the Delaware." Now, all this was reaction to the painting as *idea*. As to whether *George Washington Crossing the Delaware* is to be admired for its plastic charms—how it was painted, and so forth—I'm not sure it is anything marvelous.

INTERVIEWER: Isn't idea or subject matter important?

RIVERS: Only for the primitive and the semantically misinformed can enthusiasm for subject matter be the inspiration for painting. The roundness of a bright yellow grapefruit may make me happy for a few moments. Its juice may satisfy my thirst. I may find its genetic history engrossing, but as an artist what has meaning for me is the color I'm going to choose and where I'm going to put it on the surface and the way I put it there. What to choose and where to put it and how.

INTERVIEWER: What made you abandon the style you used from 1953 to 1955 the George Washington period?

RIVERS: You don't "use" a style and you don't "abandon" anything, the way I see it. The history of art and the history of each artist's development are the response to the discomforts of *boredom*. I don't mean boredom in a negative sense. I mean it in the sense that it would be a bore to approach a fresh canvas and once again paint in what had become personal clichés. One of my theories about the art of the last hundred years is that more alterations to the image of painting have been brought about by the boredom and dissatisfaction of the artist and his perversity than anything else. Scientific investigations into color and light in the middle of the nineteenth century didn't make Impressionist paintings, nor did the increasing strength and curiosity of the new non-nobility. But three decades of David and his influence, followed by the successful smoldering genius of Ingres, were too much for any painter with boundless feelings of self-admiration and pity. Who was going to paint the David ideal better than David? Why bother with someone else's cup of tea? In order to convince themselves, artists must think they hate it. Secretly they admire it. But they want something different . . . a life of their own. Only as old men do they realize that what they hated was not only good, but that it was inevitable that it give way to something different—as their work and everybody else's must.

4. *Berdie in the Garden*,
1954.
Oil on canvas, 61¾″ × 50¼″.
Collection, '
David Daniels.

INTERVIEWER: Have you yourself had a "de Kooning" period?

RIVERS: Yes, but don't tell anyone. Seriously, it's his earlier paintings that have stuck in my mind and which have had the greatest effect on me. The dark figure paintings of the late thirties. But I like almost everything I've ever seen that he's done. His painting from a distance seems to touch on objects and landscapes, but as you draw closer everything disappears and you see a dipsy-doodle energy that keeps pestering you long after looking.

INTERVIEWER: Could we take an example of one of your paintings and discuss it? Its genesis, and so forth. What about this one here, this portrait (Fig. 4) of your mother-in-law, Mrs. Bertha Burger, a heroine of the chair?

RIVERS: She certainly was that, wasn't she? I did twenty portraits of her, if not more; she was seated most of the time, though in a painting

5 *Blue: The Byzantine Empress*, 1958. Oil on canvas, 72" x 60". Collection, Mrs. Albert M. Greenheld, Philadelphia.

called *The Pool* I had her down on a mattress, her legs up on a couch. She was sixty at the time. She's in every museum in New York except the City of New York. Should be there, of course—in the Bronx chapter.

INTERVIEWER: Still, to judge from what you said a while back, as regards the painting your mother-in-law as subject matter is relatively unimportant.

RIVERS: The strength of the picture doesn't have to do with the fact that it's of my mother-in-law. It has to do with structure and style and color. You can turn it upside down—not that it's supposed to be—and you'll see that energy is still there.

INTERVIEWER: What about this painting here called *Byzantine Empress* (Fig. 5)? Who's the model?

RIVERS: Actually she was a Bennington girl with a slight lisp, I remember,

6. *Eula II,* 1958. Oil on canvas, 30⅛″ × 33½″.
Courtesy, The Marlborough Gallery, New York.

and a large set of bosoms. I met her at the Five Spot. I asked her if she'd like to come by the studio. I was vaguely interested in her and in doing a portrait of her. Well, when she came by she had this nutty blouse on, a sort of combination scarf and blouse covered with big fat roses—like a wallpaper pattern in the Bronx apartment of a garmentworker who leaves questions of taste up to the wife. I had her put the scarf over her head. I thought those spots would look mad on blue—which was the original background color. Then I thought it would be interesting to have the roses *look* like roses. When I was getting finished with it I decided I wanted something there on the left, something to animate the area—so I put in another arm.

INTERVIEWER: What about this portrait *Eula II* (Fig. 6)? Is this your
mother-in-law once again?

RIVERS: No. The model was a Negro maid. She was the only model I had

at the time—the only person I knew who wasn't embarrassed not to pretend to work during the day. Well, the first thing was the black —the face. I usually start with the face—a circle or an oval which five minutes later may turn into something else. In this case the face became a black streak.

INTERVIEWER: It seems almost a stroke of obliteration.

RIVERS: It might have been. I don't know. I knew only that it would be black. Incidentally, would you know the model is a Negro without my telling you? And now that you know, does it make the painting the more understandable?

INTERVIEWER: I don't know. What is this down here? Is she wearing shorts?

RIVERS: What's the matter with you? Are you blind? She had a *skirt* on. She may have been in a peculiar position, but certainly she had a skirt on. But anyway, the point is this: the George Washington painting had to do with *idea*. This painting, and the mother-in-law we just looked at, find their energy in structure, color, and style. For example, the model was wearing a blouse with a long thin sleeve. I kept widening the sleeve (that white area to the left of the red) because finally I saw her as a block. Then I wanted the sleeve to go up—like I saw her as a Stonehenge monolith. I don't know why.

INTERVIEWER: So you would admit to a strong element of accident in your paintings?

RIVERS: Certainly.

INTERVIEWER: The concept of "accident" in art seems to upset much of the public.

RIVERS: It shouldn't. It depends what happens. I mean you can bump into somebody in the park—just by accident, you know—and it can be splendid. On the other hand, you can bump into somebody else and eventually get yourself mugged.

INTERVIEWER: How does this apply in painting?

RIVERS: In painting something happens—paint falls on your canvas—and you can use it. Or reject it by rubbing it out. When Jackson Pollock decided the brush inhibited him and he began to shake paint off a stick onto canvases laid out on the floor, he couldn't *predict* his paintings, but he could *direct* them. Canvases that look the same (and anyone can tell a Pollock) must have direction. I've often heard modern works condemned on the ground that a five-year-old child could do them as well. Of course, there *are* paintings a child could do—but not *repeat*. She'll do something, but then something else that'll show you she's someone's granddaughter.

INTERVIEWER: Have you ever *invented* a shape in your paintings?

117

RIVERS: As far as I'm concerned *nothing* makes an invented shape more moving or interesting than a recognizable one. I can't put down on canvas what I can't see. I think of a picture as a smorgasbord of the recognizable.

INTERVIEWER: Could you illustrate what you mean?

RIVERS: I may see something—a ribbon, say, and I'll use it to enliven a three-inch area of the canvas. Eventually it may turn into a milk container, a snake or a rectangle.

INTERVIEWER: So it's unlikely the ribbon has any meaning?

RIVERS: I may have a private association with that piece of ribbon, but I don't want to *interpret* that association, it's impossible, it doesn't interest me. Some painters think that associations with real images are terribly strong, and that people in general identify the same meaning with them as they themselves do. I don't think so. The associations which arise from objects or events are hardly *ever* the same. Therefore, I feel free to use the appearance of a thing—that piece of ribbon—without assigning any specific meaning to it as an object. And besides, the only qualities you can take from an object for use in a painting—at least as far as I'm concerned—are its shape and color. You can't use the actual texture or the function.

INTERVIEWER: A while ago you described your paintings as a "smorgasbord of the recognizable." Could we look at one of your more recent paintings—*Second Avenue with THE*. Certainly the smorgasbord quality is there, but how about the recognizable?

RIVERS: What you see is the view from a studio on Second Avenue—a top-floor studio—looking across at the buildings opposite. The canvas shows a selected few of the multitude of objects I could see from where I stood. The rectangles are reflections from glass windows across the street. The dark vertical lines are the studio floor boards. I looked down, saw them, and painted them. The horizontal lines are the window sills. The semicircles on the right are the rims of a drum. The line of little white squares are the white keys of a piano I had there in the studio. And the rocket-woman figure, she was in the studio too, a statue which was in my field of vision. That little shape up there by the letters THE—just to the left—that's a woman leaning out of a window opposite. I should have had the letters ALPINE up there too. That was the title—a chic one, don't you think—some builder had given one of the buildings.

INTERVIEWER: What about those letters THE?

RIVERS: Those letters were pasted on the studio window by some movie director who photographed them for THE END of his picture. The END part of it had disappeared.

INTERVIEWER. All right, you've explained three of your paintings, all strikingly different in execution. You said a while back that boredom was the catalyst in your evolution as an artist. Some artists, though, appear to decide upon an interest and pursue its ramifications with no apparent restlessness. If they change their work, it's very gradual. Does this consistency of interest spell integrity to you, as it does to some of the critics?

RIVERS: Hammering away hard at a square or a figure all your life is the usual notion of dedication and integrity. But it seems to be very much like the guy who insists on wearing the same outfit. He puts on his gray flannel suit, his white shirt, his black tie, and suede shoes, and *never* is seen in anything else. And slight deviation makes him nervous and embarrassed, makes him feel that he isn't presenting himself in the "best light." The weight of anything resembling contradiction is unbearable. He believes in the absolute. I'm sympathetic because I don't think he has a choice no matter how modern or advanced he is, and no matter how many people are carried away by his painting of seventy-two square feet of cadmium yellow unadorned by a recognizable figure.

INTERVIEWER: So you wouldn't associate the word integrity with those seventy-two feet?

RIVERS: Seventy-two feet of cadmium yellow isn't my idea of it. I don't hate it, but it does seem artful, and perhaps it's "aristocratic" too, by which I mean it's a form of artistic shyness, controlled, an avoidance of embarrassment. "Aristocratic" is what I feel in certain society people—a sense of containment. I like self-containment, emotional constriction, but not that much. . . .

INTERVIEWER: Can it be that the adulation some of these "aristocratic" paintings inspires bothers you?

RIVERS: It bothers me more than the paintings.

INTERVIEWER: You are concerned, then, with what goes on in contemporary art?

RIVERS: Yes. And I am bothered by it: for example, by the formulation of so-called "pure" painting. Its specific demand for *non*-association is similar to the nineteenth century with its insistence on the *proper* association. Certain painters will not allow a recognizable image in their work (or anyone else's) just as the nineteenth century scorned a painter who didn't make the image recognizable. Today, the figure is the hardest thing in the world to do. If it doesn't turn into some sort of cornball realism, it becomes anecdotal, it seems. Today, knowing the odds against you, the figure seems a *stupid* choice. But if the problem is one of choosing between being bored and being chal-

lenged, having to do the difficult, I'll take the latter.

INTERVIEWER: What are some of the other difficulties you face?

RIVERS: Well, here's the sort of thing. In the past you could walk right up to a painting if you were attracted, and the nearer you got the more intimate you felt with the work. There was something to examine close up. Today it doesn't make any difference *how* close you get, you're still just as far away as you were. There's nothing to learn from detail. Paintings are done close up. But today their impact is at a distance—the kind of painting that looks the same thirty feet away as it does at five feet. They're practically made to be in buildings. But I think there *should* be an appreciable difference in being near, in the detail. I thought that used to differentiate me from the others, but it's fading fast. I'm trying to hold onto it. Just to add to my difficulties, I was talking to the painter Grace Hartigan the other day and she agreed with me. She said, "Yes, what is detail today?" Very depressing.

INTERVIEWER: Do you mean to say that what goes on in contemporary art has such an effect on you that it forces changes in your work that you don't even approve of?

RIVERS: Well, you try to paint for yourself, but there's a big tide and you go along with it. I'm being dragged. "But, fellas," I keep saying, but they keep pulling. Hell, you're interviewing a dying man. I don't feel like getting up there and shouting "Put in more detail!" I mean there used to be the Fifth Avenue double-decker bus, which I liked about as much as anything, but it's gone.

INTERVIEWER: But how then can you say that you prefer taking up a challenge? It seems to me that you have one right here.

RIVERS: Well, the fact is I *am* taking up the challenge. I have in mind, before *everything* disappears from my painting, a picture to be called *ME*. It will be an extra-extra-large canvas, with glimpses of everything that's happened to me from birth to the present. I expect it to go down in history as the most egomaniacal painting ever. (*At this point the artist's son, Steven, said he would have to be in it because he had happened, and the artist agreed.*) Of course, it never turns out the way you think it will. As soon as I've touched the canvas with a brush, fifty percent of my previous ideas have gone or changed into something else. It may end up completely blank, and if it does I suppose I'll have to renege on those cracks about seventy-two square feet of yellow. I'll have succumbed to embarrassment.

Helen Frankenthaler

The beauties of Helen Frankenthaler's work are various and dramatic. As much as those of any contemporary, her major works signify the whole psychic figure and it is all there: back, shoulder, arm, wrist, hand and eye —she is a dashing and irresistible artist.

As one of the important young painters of the New York School, Miss Frankenthaler holds a position of individual achievement which commands respect and excitement. Her sensibility is to me very "fifties"; her tradition, to use the phrase of Harold Rosenberg, is the "tradition of the new" to which she brings her own authoritative, and at times speculative, lyricism as a heightening presence in each occasion of risk and paint-adventure.

This sensibility is inclusive and generous, free-ranging and enthusiastic. One of her strengths is this very ability to risk everything on inspiration, but one feels that the work is judged afterward by a very keen and even erudite intelligence. Headlong as her moments of creation would appear to be, one also senses behind the apparent disregard for the "look" of anyone else's painting a profound awareness of pertinent elements (to

121

1. *Mountains and Sea,* 1952. Oil on canvas, 7'2⅞" × 9'9¼".
Collection of the artist (on loan to the Metropolitan Museum of Art, New York).

absorb or to avoid) in the developments of Kandinsky, Gorky, Pollock and Miró.

The development of her own work has tended away from the deliberate construction of a picture. This is not to slight certain paintings of the early fifties which did employ conscious spatial manipulation and heavier impasto in the handling. At that time, after *Mountains and Sea* (Fig. 1), necessary formal speculations were advanced, particularly in several abstract landscape motifs which culminate in *Mount Sinai* and *Jacob's Ladder* (Fig. 2), and would relate less directly to *Before the Caves* (Fig. 3) and *Madridscape.* A remarkable painting of this earlier period is *Ed Winston's Tropical Gardens,* a powerful, almost hilarious abstraction, and two other fine ones, *Blue Territory* and *Trojan Gates,* are in the collections of the Whitney Museum and The Museum of Modern Art, respectively.

One of the crucial decisions for the contemporary artist, representing a great conflict in temperament, is the very question of conscious com-

2. *Jacob's Ladder*, 1957.
Oil on canvas,
9′5⅜″ × 69″.
Collection,
The Museum of Modern Art,
New York; gift of
Hyman N. Glickstein.
Photo,
Rudolph Burkhardt.

position, whether to "make the picture" or "let it happen." Cubism says one thing and Surrealism the other, both influences persisting in a variety of interpretations and guises. Each has its pitfalls, the one dry formalism, the other a complete mess. I do not know that one area of risk is greater than another, and doubtless the strong temperament finds that no decision can be made: it must be one thing. Frankenthaler's preference is apparent in *Mountain and Sea* and in later drawings and sketches. During the intervening years of more deliberative work this decision is constantly growing, turning up on sheets and scraps of paper, on the backs of menus and hotel stationery.

In *Towards a New Climate* (Fig. 4) her preferred direction takes over completely. It is one of the key works in her development. Done, if I re-

4. *Towards a New Climate,*
1957.
Oil on canvas, 70″ × 98″.
Collection of the artist.
Photo,
Rudolph Burckhardt.

3. *Before the Caves,* 1958.
Oil on canvas,
102″ × 104¾″.
Collection of the artist.
Photo,
Rudolph Burckhardt.

5. *Eden,* 1957. Oil on canvas, 103″ × 120″.
Collection of the artist. Photo, Eric Pollitzer.

member correctly, in despair, it sings freely and with originality of a new
space and a new individual inhabiting that space, naturally and with
unerring delicacy. It is single in event, yet enormously allusive and subtle.
Existing *in* the canvas like stains, it is perfect in detail, revealing exten-
sions of space within and beyond the surface while the actuality of this
surface is adamantly contained by the hand of the painter. This painting
presents, as well, a statement about the meaning of art to the artist, par-
ticularly to the artist in the act of "receiving" lyrical insight. For in the
reception of this psychic meaning, the artist, as if unknowingly or
subconsciously, retains identification with the simultaneous art-experience
and inspiration can transform the experience by being united with it. We
find this occurring again and again in the works that followed. **125**

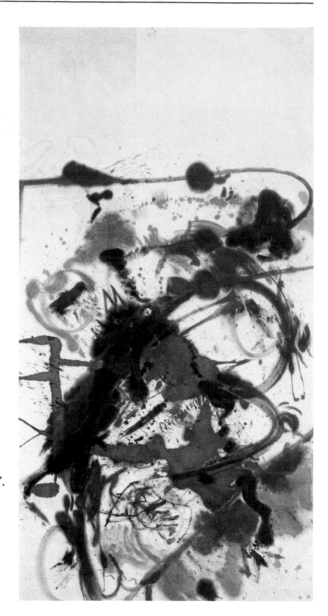

6. *Winter Hunt*, 1958.
Oil on canvas, 91″ × 46½″.
Collection of the artist.
Photo,
Rudolph Burckhardt.

Frankenthaler is a daring painter. She is willing to risk the big gesture, to employ huge formats so that her essentially intimate revelations may be more fully explored and delineated, appear in the hot light of day. She is willing to declare erotic and sentimental preoccupations full-scale and with full conviction. She has the ability to let a painting be beautiful, or graceful, or sullen and perfunctory, if these qualities are part of the force and clarity of the occasion.

The range of her emotional subject matter is very wide. The erotic overtones can have the sweetness almost of a Watteau (*Before the Caves, Jacob's Ladder*) or a kind of irony resembling that of early Goya (*Eden* —Fig. 5, *Venus and the Mirror*). On the sentimental side, the superb *Mother Goose Melody* and *Sea Horse* do not fail to refer to emotional enthusiasms which are real and amusing and likeable, but surely these emotions would be found silly in the higher-consciousness areas of the city, like having a fondness for Jean Harlow movies or *The Boyfriend*. At the same time, I feel that *Winter Hunt* (Fig. 6), *Madridscape,* and *Hotel Cro-Magnon* are tragic in tone, without any insistence that the emotion is more major than those contained in other works. This is a very attractive quality and it shows a sense of justice toward the individual work.

It is difficult to know an artist's work in any kind of perspective without this mutual elucidation of periods, forced as we usually are to experience each phase singly at one, two or more years intervals and make connections based on memories of gallery and group exhibitions. It is a splendid thing that through The Jewish Museum's hospitality these paintings were brought together and illuminate each other's qualities.

Introducing the Sculpture of George Spaventa

George Spaventa has had a quiet, doubt-ridden, essential development. His work is special, in the best sense. His affinities are with the plastic qualities of Rodin, Medardo Rosso, and Giacometti, and he has maintained them in a stubborn, personal way without any obvious influences from Constructivism, Cubism, or Mannerism à la Zadkine. Surrealism, too, seems almost totally absent from his work, although refrains of literary content are not, especially in relation to Kafka and Cervantes in his sense of caricature. Perhaps the only aspect of Surrealism he has bothered with is the much-neglected humorous one. There is none of Dada in him. One can only conclude that his influences are those of individuals rather than schools, of personalities rather than movements.

Much of the emphasis in important recent sculpture has been on material and technique, on the incorporation of found or industrial elements, on the actions of welding, cutting or assembling in general. In Spaventa, the emphasis is on the hand, and handling. With the single exception of Nakian, it is difficult to think of an American sculptor who has insisted more upon the imprint of his finger, thumb, wrist and arm. Sensitivity to the material is there, but first and foremost the material

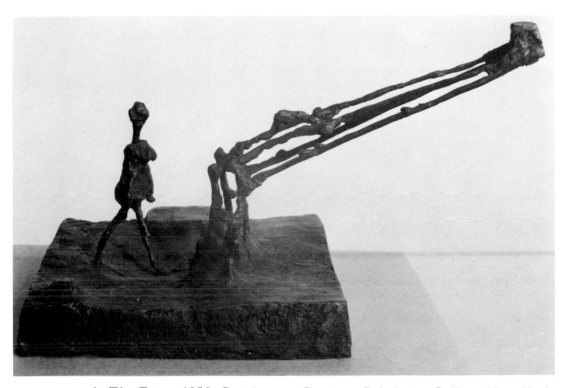

1. *The Entry*, 1956. Cast bronze. Courtesy, Poindexter Gallery, New York.

itself is required to be capable of sensitivity to Spaventa. If it remains obdurate he does not bring out his blow torch, but like a wounded lover turns his back.

His chief materials are therefore wax and plaster for casting in bronze. These physically sensual materials respond subtly (and sensuously) to his basically introspective (and intellectual) aims. In many of his figures he makes us feel isolation as a kind of cosmic repose, like the Egyptians do, and like them Spaventa has a cool, hierarchical and distantly comic attitude, feeling simply and irreducibly that man is the final and ultimate image, almost in desperation at having failed to find others—there is no Greek or Roman conceit to the belief.

These "images of man" are neither languishing in banal Hiroshimaesque profundities nor frothing with Pop Artistic ironies. They can be harassing (*The Entry*, 1955—Fig. 1), implacable (*Sculptor's Table*, 1957—Fig. 2), intimate and inexorable (*Sculptor's Studio*, 1956) or ominous (*The Search*, 1954), without reverting to any Existentialist clichés of feeling or departing from Spaventa's own view, a view which would seem almost philosophic were it not for the intimacy of the han-

129

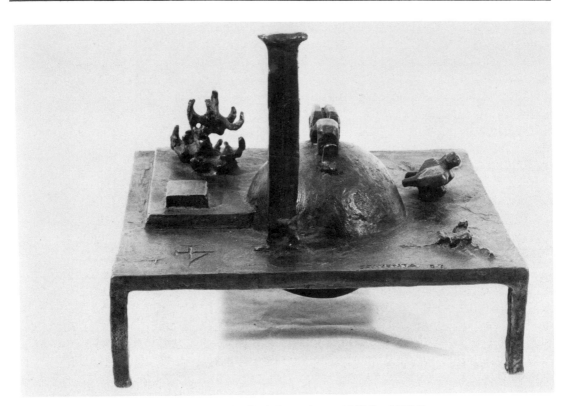

2. *Sculptor's Table,* 1957. Bronze, 8⅞" high, at base 10⅞" × 10⅞".
University Art Museum, Berkeley; gift of the Longview Foundation.

dling, and the irony, sometimes strong, sometimes faint, of stance. His irony is inner-directed toward a conception based on observation rather than idea: I am thinking of the humor in such pieces as *Head,* 1956, *Pregnant Woman,* 1954, the Don Quixote atmosphere of *The Actor,* 1956, the traumatic "stuckness" of the standing figure in *The Gesture,* 1954, and the veiled obscenity of the *Seated Figure,* 1962, whose unconscious ritual, if I am not mistaken, is nothing less than the copulation of a Rodin motif with a motif of Lipchitz (Fig. 3). But Spaventa himself needs no specific reference for such a subliminally outlandish creation, because I suspect he feels it all as part of a total mess or mud, out of which he drags, pushing and squirming, his configurations. The semi-stasis of these figures, so exquisitely or humorously modeled, is held in a state of tensility based on anxiety: neither Spaventa nor they are able to believe they are quite out of the muck yet. That some of the major new works in the exhibition at Poindexter Gallery remain untitled at this writing [1962], betraying a specific action, rather than portraying or identifying

130

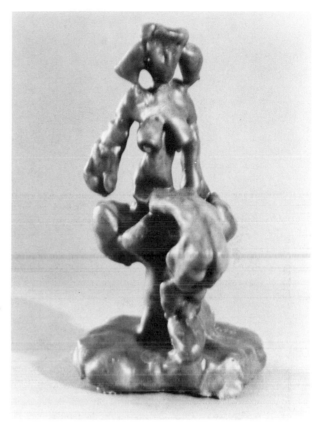

3. Seated Figure, No. 2,
1964. 11½″ high.
Courtesy,
Poindexter Gallery, New York.

it, is witness to the wholly instinctive approach Spaventa has to that most overt of forms, the human figure. His relation to these "characters" is not too far removed from Sartre's description of Genêt's relation to his, in anxiety especially.

That we must know more about these resistant personages is very clear, and a measure of Spaventa's achievement is that within them dwell a multitude of atmospheres and emotional ambiguities. They seem to alter the space around them by their intentions rather than their simple presences. Within the complex of each work, the figure's attention is often absorbed by something inside itself, or inside the environment, or the air —a fragrance, a memory, a half-made decision which has nothing to do with motion or drama. The figure standing before *The Entry,* an entry which is shaped like a sling and huge in scale, is neither advancing nor retreating, but the emotional ambiance is nothing so simple as witnessing or waiting. And the artist walking away from the *Sculptor's Studio* is not really leaving it, but seems rather to have turned his back on it forever; **131**

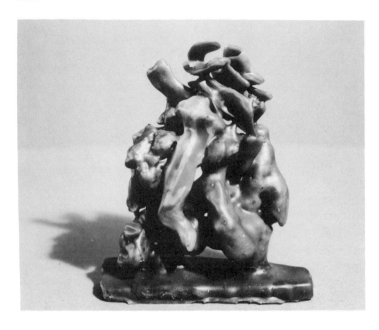

4. *Walking Sculptor*, 1964.
Cast bronze,
7″ base, 8″ high.
Courtesy,
Poindexter Gallery,
New York.

this latter is one of the most poignant works created around the death of Jackson Pollock, a masterpiece more forlorn than a visit to the artist's grave, because the artist is still alive in it.

Spaventa's sculpture has been enriched by a totally serious and totally difficult search for unequivocal expression, and fortunately its resolutions retain the dilemma and the passion of this search, as if metaphysics were to be felt emotionally. Much of contemporary sculpture has dealt with the concept of sculptural motion brilliantly (one thinks of Boccioni, Calder, Tinguely), but for Spaventa the sculptural situation seems more to be a definition, a psychological stopping-point or arrest, sometimes tragic, sometimes rejuvenating, always formally essential to the still organism. In his equation, motion is the signal for the arbitrary, and he is devoted to its opposite.

That he should have this first New York one-man exhibition when he is in his mid-forties is not without recent historical precedents, most notably that of Willem de Kooning. For the last ten years his sculptures have emerged before the appreciative eyes of the most critical audience in the world: his fellow artists, chiefly the New York Abstract Expressionists. What is apparent now in these works is mastery, decisiveness, and scope. The accumulation of years of self-examination and esthetic intransigence (Spaventa was born in 1918 and studied both in Paris and New York) has yielded a full, rich, and spontaneous expression of a very particularized, very important spirit. The question of spirit is vital to an

understanding of his originality and spontaneity. His is not the freshness of the spontaneous materials favored by the Assemblagists, but a freshness of the spirit which whispers to us, "Within . . ." and trails off into the atmosphere of greatness, glimpsed and captured. It is a tangible quality for all its allusiveness.

In the works of the sixties, he shows a new relaxation in following the dictates of his inspiration with no loss of grandeur, but rather a quickening of impetus (Fig. 4). He fixes the precise moment of physicality with a mysterious, enlarging accuracy. Spaventa is one of those "happy few" whose work is absolutely essential to the art-life of America because it is close, intimate, ungeneralized, a witness of the most positive, and ambiguous, elements in our culture. His struggles are as meaningful as his successes because they are based on the highest of aspirations. As Blake said, "To Particularize is the Alone Distinction of Merit." Thus, George Spaventa brings a new conscience to American sculpture, a conscience as much concerned with what the artist is, as with what the human does.

Growth and Guston

Philip Guston has, characteristically, a kind of introspective aggressiveness toward art which is capable of providing the best of two worlds simultaneously. Through most phases of his work there runs a constant interior, and at the same time very ambitious, dialogue with art both past and present. In the earlier work there is a certain amount of secretiveness resulting from the symbolic elaboration of his content, but then Guston turned away from the overtly figurative, and he has become clearer and more spontaneous in meaning ever since. (I mean spontaneous not in the sense of an impulse like anger, but in the sense of attention, that which the artist is attracted to beyond its ostensible appeal.) It is as if he had no longer found it necessary to have a pictorial pretext to do the painting that was in him.

The early paintings, which were already served by considerable gifts, took an individual stand somewhere between Romantico-Surrealist and veiled Social-Realist interests. There were haunting reminders of Chirico, particularly. The formality of structure, the sense of traditional iconography taken from a fresh point of view which had little or nothing to do

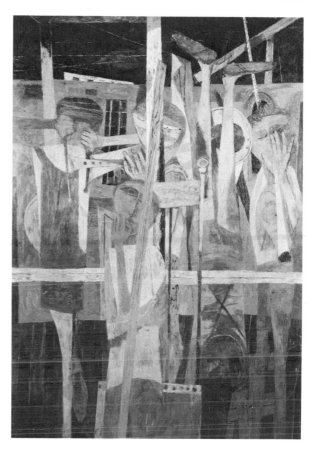

1. *Porch, No. 2,* 1947.
Oil on canvas, 62½″ × 13″.
Munson-Williams-Proctor
Institute,
Utica, New York.

with the trappings of the two schools mentioned above, and a definite and decisive attitude toward the perceived color of natural forms were the great signs of what was to emerge. One need only think of an Iowa City street which has the fatalistic aura of a decaying Roman vista, the visual metaphors in *If This Be Not I,* the rose vine tied to a post with rags, the juxtaposition of the girl's tinsel crown with the crown of thorns nearby, the crucifix-like composition of *Porch, 2* (Fig. 1) complete with its "St. Peter" upside down, the dreamy mannequin treatment of the figures, to know that a very unusual sensibility is at work. This period is beautiful in paint quality and it is extraordinarily rich in imagery both allusive and analogical. But the imagery, especially the metaphysical aspects of it, is always kept at the service of the content, it is always partially submerged, so that both subject and its analogical or allusive variations are almost invariably subservient to painterly considerations. It is perhaps the reason for the air of secrecy which surrounds and pervades these early works.

Actually, the next move toward abstraction, after the painful self-facing of such paintings as *The Tormentors* (1947–48), was from the sub-aqueous into the light, from allusive structure and analogical imagery into the openly anxious ego-identification with spontaneously found "signs" which grew on the canvas like grass to become a field of painted light. Where ambiguities exist under such direct dictates of the artist's sensibility, they are more valuable than icons. The "lost world" of the masquerading children in the early paintings, of the muted musicians, of the never-never land Depression porch-watchers, was found, though Guston's propensity for content, for subject matter, was to become more rather than less explicit as his art became more intimately related to the physical relation of his body to his paintings and to the psychic relation of his subconscious to his way of seeing. But this is not to say that the earlier works have now for us the flat, illustrational or historical meaning so much "allegorical" painting of the thirties and forties has: he illustrated no pat anecdotes and no psychological situations. The figures dwell in a self-contained but unsolved relation which they create before your eyes and do not themselves understand: therefore they remain today in a stylized stasis of complex anxiety, fear, and peril, melancholy, but never protesting or fleeing.

Guston seems never to have had to fight against the learned habit of conceiving painting-space as essentially Cubist which has plagued as well as benefited so many major American painters, and when the new space approached him through increasing complications of imagery stimulated by Surrealist emphasis on the subconscious he was able to make it his own in a very personal way. The process seems to have been a peeling away of the layers of appearance from the painting experience.

Beginning in the fifties Guston purified his painting to an extreme degree of sensivity: in the two *White Paintings* of 1951 there is virtually nothing but the contact of the hand with brush, the brush with canvas, exploring with sparse means the luxurious personal joys of drawing. These paintings are both intimate and masterful, as are their ocher companions of the same year, ascetic and sensual. Other paintings develop clusters or fields of strokes laid near to each other or relatively far apart with a justness which now seems to join delicacy of feeling with inevitability. No longer were his dialogues with Chirico and Giovanni di Paolo, but with the more abstract landscapes of Cézanne, with Tiepolo, Turner and *not* the late Monet. In finding instinctively a closer relation to Impressionism than to Cubism, Guston confirmed an already hierarchical attitude toward form, nonanalytical, concerned more with the light which was to emanate from the canvas than that which was to fall on the plane. It was another way of being nondescriptive, and in discovering

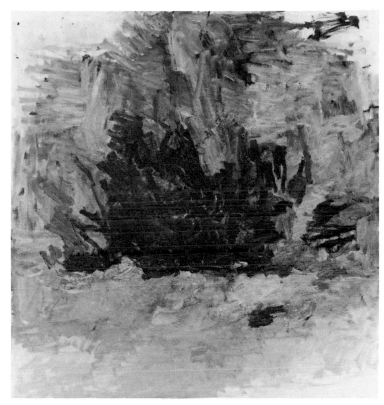

2. *Bronze,* 1955.
Oil on canvas, 76″ × 72″.
Minneapolis Institute
of Arts;
The Julia B. Bigelow Fund.

it he reversed the procedure of the Impressionists, creating for the eye a series of original optical "scenes" which might later be found in nature under exceptional circumstances of light, but which had nothing to do with the observation, analysis, and recreation of nature's own light-phenomena.

This period includes a number of major works: the brooding, elegiac *To B.W.T.;* and at the opposite end of the emotional spectrum the crisp, airy strictness of *Painting 1952,* where seemingly arbitrary strokes of color adjust themselves like a very personal tribute to Mondrian; from the roseate loveliness of *Attar,* whose structural strength is merely whispered, to the blazing *Painting 1954,* there is an enormous range of expression.

With *Beggar's Joys,* and its companion painting of 1954–55, *The Room,* we find the strokes gathering into masses in a vulnerable, questioning space, poised pensively, falling or lifting in a subtle drama of equilibrium. This drama becomes heavier and more demanding in *Bronze* (Fig. 2), more formal in *For M,* where the dominant central mass spreads like an Infanta's skirt or like a landscape without sky. There is the sense of

137

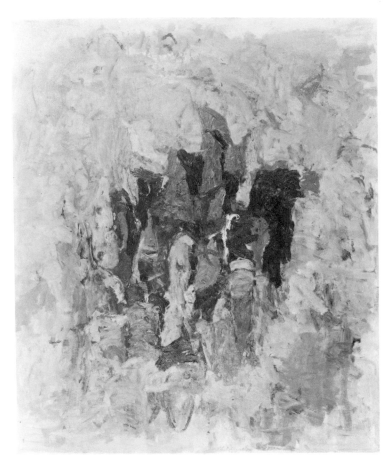

3. *The Clock,* 1956–57.
Oil on canvas, 76″ × 64⅛″.
Collection,
The Museum of Modern Art,
New York; gift
of Mrs. Bliss Parkinson.

an unseen presence in these latter works, perhaps of an actor who has just abandoned the stage or of a voice which has just died out.

Out of this drama in the next years came a number of decisive revelations in Guston's art. *Voyage* and *Dial* (both 1956) are reticently joyous in their positive assertion of centralized masses, vivid in color, sensuous in paint-handling, detached and lofty as Baroque ceilings. The strokes become larger and more affectionately aggressive in many of these paintings, the forms expand. A series of small oils further enlarge and space out the color-forms on the plane, as if abstract figures were almost emerging in a verdant landscape of arbitrary color reflecting some non-existent season. *Cythera,* a large homage to Watteau, is noble, sensitive, and unabashedly tender. At the same time *Oasis,* also of 1957, seems to create darkness with bright colors, and a somber, majestic foreboding is found in *The Clock* (Fig. 3), one of Guston's masterpieces. Again, the

4. *Fable,* 1956–57. Oil on canvas, 75″ × 65″. Collection, Washington University, St. Louis.

new freedom of handling and richness of texture becomes almost Soutinesque in the more abstract *The Clock, 2* of that year.

New techniques developed during the explorations of these paintings; while the intellectual content of the paintings increased, if anything, the new sensuosity in handling brought a new dramatic directness to the paintings which were emerging, a drama which this time was directed toward the flesh, and which added to his already formidable technical apparatus that of the juggler, the equestrian, the tragedian. The surface of the painting may now take on the feel in your hand of the Indian clubs, of the hide of the horse, of the pain of another physical presence which has hurt you or is driving you mad. Added further to these qualities was a new irony, fatalistic in some works, humorous in others, an irony based largely on the abstractness of the drama being unfolded.

The first of the full, detailed paintings of abstract incident, where **139**

5. *The Tale,* 1961.
Oil on canvas, 68⅛″ × 72″.
Collection of the artist.

forms meet as fantastically and as logically as in Uccello, were *Fable, 1* (Fig. 4) and *Painter's City.* These, along with *Rite,* seem modern fables of chivalric intentions, of gallant notions not-quite-hopelessly entangled in a strong and perverse milieu. The "figures" spread horizontally across fields thick with action and counter-action, as if a worldly, sophisticated person were recalling in the light of present experience his childhood imaginings of the *Morte d'Arthur.* These works have another kind of intimacy from the earlier ones, the intimacy of candid self-exposings, of noble sentiments confessed in the hard, ironic light of contemporary life. *Nile* and *To Fellini,* however, return to the somber, haunted mood of earlier paintings, and *To Fellini* in particular, Guston's homage to the director of *I Vitelloni* and *The White Sheik,* has a dark, carefully formulated and masterful lyricism.

The 1958 series of gouaches are lighter in tone, even genial. The larger (in scale) and brighter forms play definite roles in the theater of the artist's mind and hand. They pose, stand indecisively, push each other and declaim: they are all purposefully directed and prepared to play subtle comic or mock-histrionic roles in scenes which may have the flooding delicacy of a light-jell or the density of a back-drop. Here Guston is not

only pondering the equilibrium of masses in the plane of his own discovered space, but makes subtle references to the mind contemplating the psychological ambiguities of its body's equilibrium on earth, the imaginary earth of the juggler and the actor, whose aspirations toward movement never quite definitely allow them to be established there with any degree of security. No symbolic aura is about these forms: they seem alive.

After the gouaches, the new oils have taken on an even stronger identity, an even more severe bulk of imagery. A passionate thickening of impasto and quickening of movement characterize most of the works which follow. Such paintings as *Poet; Grove, 1; Painter, 1;* and *The Tale* (Fig. 5) have a new amplitude and grandeur, a stern seriousness of purpose and conviction. They are summations of feeling painted with an almost luxuriant intensity, compounding textural and formal ambiguities of the "finding" of the painting into images of great certainty and power. There are no figures, the images are material presences, like Druidic spirits, which inhabit the paintings. The forms clutch and contemplate, move slowly upward or recline somberly like fallen heroes. However, they are never formularized: *Poet, Painter,* and *The Tale,* the latter another masterpiece of Guston's oeuvre, explore the uneasy triumphs of self-realization through painting, while the *Sleep Series* and the *Actors Series* are involved with a widely different, but no less successfully achieved, range of feelings. Seen in yet another aspect, the formal insights of these works, including the more recent *North* and *The Scale,* the marvelous burgeoning into life of their surfaces, the visual velocity of the painter's unerring hand make of Guston's self-imposed demands simultaneous triumphs.

Alex Katz

I think Katz is one of the most interesting painters in America. He has the stubbornness of the "great American tradition" in the dominating face of European influences—more in the spirit of Winslow Homer than of Prendergast, for example—and the ability to understand, or better, interpret an enthusiasm so it will work for his individual interests.

In the early fifties the example of Cézanne made him want to do "all-over" paintings like Pollock and Guston were doing, and to understand why they were doing them. A further stubbornness led him to want to make the all-over paintings all-over paintings of trees and the patterns of their leaves in the light, which leads us right back to Cézanne. Two years later, in 1953, Pollock himself was to show *Blue Poles* and *The Deep,* two works which despite their almost total abstraction have certain naturalist referents beyond the association obviously indicated by the artist's choice in titling. And one of the most moving aspects of Guston's work has been the continuing reference in it to a subtle emotional naturalism, the paint as rock, the rock as head, the head as cloud, the cloud as thought-in-paint. In this operation, whether conscious or not, Katz

was pulling together his enthusiasms and influences into a congruent assemblage, reinforced by his equal passion for Matisse and his interest in what Milton Avery had seen in Matisse. He freed his own painterly feelings and widened their range of possibility precisely at the moment when he was focusing them on a specific intention.

At present the progression I have sketched seems rather unexceptionable. Pollock is now a recognized master, Matisse a god, Guston renowned. But in the fifties, fruitful as they were for the art of all Western nations, New York itself was inundated by the German, as well as Abstract, Expressionists and few figuratively inclined artists could withstand the onslaught. Katz and Larry Rivers are notable exceptions, and the thanks for maintaining their originality of position in relation to their respective tendencies toward imagery was to have been belatedly assigned to the "camp" of Pop Art, variously as Fathers or as Followers—as totally erroneous an attribution as the current allegation that certain younger artists have "given" de Kooning ideas. One can only wish that they had gotten more ideas from him, and that some of the Pop artists had paid closer attention to what Rivers and Katz, in their different ways, were doing.

Ideas which did appear to emerge within a very short time: Willem de Kooning's *Marilyn Monroe* and "Woman" series, Katz's series of *Ada* slightly later, and then later (though Katz's *Ada* series is still continuing) Andy Warhol's series on Marilyn Monroe, Elizabeth Taylor and Jacqueline Kennedy. However historical these emergences may seem to us in our collapsed-space-capsule attitude toward recent art, all appeared within an immediately contemporary context, not, as some critics prefer to prescribe, marking epoch-making differences: the imperative need in American painting for the radical treatment of the figure in a manner which was personal to the painting impulse of the artist rather than conceptual in a "communication" sense. Each in his own way: and the stylistic strength of each holds the figure painting in the grip of the total oeuvre: de Kooning's with his abstractions, Katz's with his landscapes, Warhol's with his Brillo boxes. There are no losses of specificity, but there are no discrepancies between modes of operation.

Katz's "break-through" in 1959 was toward enlargement of image, a move away from personal characteristics in the handling of paint, in order to emphasize the abstractness of the subject and the inherent values it possessed, and which he released. Warhol later accomplished this through the use of silk-screen methods which became highly influential (though never with his particular zing), and both artists were taking the opposite position from de Kooning's, whose women had become abstract

143

through the extreme personalization and primacy of emphasis on paint-handling, the figure an inspiration for sublimely virtuoso performance in which the painting act revealed its capabilities for surcharged emotion.

For Katz the image, and his TV, billboard, or movie close-up discovery, provided a way of both isolating and abstracting each separate feature, as if it were an arc, a rhomboid, an ellipse, within the psychological unity which the audience imparts to a recognizable form. Although he continually paints faces, and they frequently look like the subject, his painterly interest is about as portraitish as Mondrian's in *Trafalgar Square*. He invariably drops the sitter fairly early on, and finishes the painting alone in his studio as a fact in itself. For Warhol the photographic image provided the opportunity to iconize or assemble in compositional series a number of images, both frivolous and grand, depending on the painting, the complete assemblage of faces of Jacqueline Kennedy in black on violet ground being especially notable in its cool force. (Lately he has carried this even further, into the static use of cinema as time-recorder, in many instances, of what could have been the subject of one of his paintings.)

Katz, obviously influenced by the flat, mat de Koonings of 1938–45 in the application of paint, has a smooth, hard surface in his best paintings. When he errs it is toward the Impressionist-Fauve, areas of early Matisse and Marquet, estimable enough in themselves, but Katz's work cannot stand the slightest hint of luxuriousness or sentiment because the underlying rigidity of structure, however subtly manifested, forbids it. His realization of the head or figure in a plane of color or pattern has decided to be as strict in its sense of pictorial decorum as Barnett Newman's or Kenneth Noland's. This is not to say that he does not get subtleties of facial expression, of psychological observation and of stance, in his subjects, but they are extra rather than primary pleasures. (Of a recent painting he remarked, "I painted the make-up.")

The isolation of a visage (and within it the component parts) in a richly colored space which would be anonymous were it not for its painterly "character" again reminds one of Newman, whose stripes do not exist in an anonymous space because the character of that space, its color, dimensions, and texture, equal the slender hieratic signal of the total work's intelligibility.

Katz's landscapes are also very important, because through them Katz has found a liaison between the personal and the general, the intriguing dialogue without which one is left with either formalism or expressionism. Beginning with the all-over "tree" paintings, Katz moved, mostly during summers in Maine, toward increasingly abstract land-

1. *Summer Series (Neil Welliver)*, 1965. Oil on masonite, 15″ × 13¼″.
Courtesy, Fischbach Gallery. Photo, Rudolph Burckhardt.

scapes and increasingly accurate coloration in them in terms of the values in the paintings: he discovered the force of schema. Upon the strength of this discovery in his consciousness depends a good deal of his most excellent work: the collages, the cut-outs, the heads (Fig. 1).

One of the most often discussed problems of New York painting in the mid-fifties was that of the figure. As de Kooning postulated it, what is its environment? Is it naturalistic, a return to regional or provincial painting, is it illusionist or symbolic? Or is it just paint? De Kooning's alarming solution was an environment of paint as miraculously deft and beautiful as the figure itself. Katz's less-known but much-discussed (among painters) solution was a "void" of smoothly painted color, as smoothly painted as the figure itself, where the fairly realistic figure existed (but did not rest) in a space which had no floor, no walls, no source of light, no viewpoint. Unlike de Kooning's Women, they were not looking at you; unlike Larry Rivers's figures and nudes, they had no attitude and no atmosphere; Katz's people simply existed, somewhere. They stayed in the picture as solutions of a formal problem, neither existential nor lost, neither deprived nor dismayed. They were completely mysterious, pic-

145

2. *Frank O'Hara,* 1965.
Cut-out,
paint on plywood, 5' high.
Collection,
Mrs. Elaine de Kooning.
Photo,
Jacob Burckhardt.

torially, because there seemed to be no apparent intent of effect. They knew they were there.

Katz then proceeded to remove even the "void." He began to paint figures which he then cut out of the plywood, thus removing any possibility of a pictorial space or environment (Fig. 2). Wherever they stood was their environment. Like the flat figures imported into England from Vienna to scare off burglars from the hearth, they assumed a presence so extreme that one painter who purchased a cut-out was terrified each morning that a thief was standing beside her bed and was relieved to lend it to an exhibition. Another figure, an attractive girl in a bathing suit, has invariably elicited the male response of looking around to the back to see if

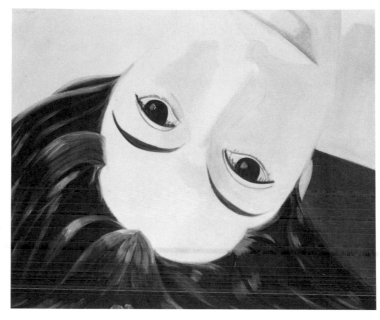

3. *Upside Down Ada,* 1965.
Oil on canvas, 5′3″ × 4′4″.
Courtesy,
Fischbach Gallery,
Photo,
Rudolph Burckhardt.

the suit continues. It doesn't. This is a kind of gamesmanship which Katz
is able to play rather more testily than entertainingly.

Perhaps the most exquisite development from the discovery of
schema is the series of tiny collages, usually no more than six or eight
inches high, which employ often minute elements of paper painted with
watercolor to reveal a gentle, pastoral vein in Katz's sensibility and an
affinity to the kinder aspects of the Bauhaus through their subtly phrased
and angulated "occasional" subjects. Here the scale is as miraculous in
miniature as the close-ups of heads are in large. Three people coming over
a hill, a raft in a lake, a boat in a bay, each conveys a simultaneous vast-
ness and intimacy. The size is intimate, but the scale is vast. They are cut
out in the most extreme sense. The space itself is cut out. And in the
sensitivity to that very firmly and delicately established space there is
more than a hint of Rothko's influence in pictorial intensity, but also an
irony which will not yield to the other's spirituality.

Katz's major efforts and achievements are nevertheless with the
figure. The heads and figures of his wife, Ada, give this beautiful woman,
through his interest in schema, a role as abstract as that of Helen of Troy;
she is a presence and at the same time a pictorial conceit of style. In each
painting he finds new features of her iconography and new implications
in those features. As with his landscapes, this head is the subject of trans-

147

formations without losing identity as an image: in the most classical and most contemporary sense, a motif susceptible to variations of feeling and, like a high fashion model, to the accumulation of properties and roles, cars, sunglasses, hats, smiles, enigmas—when this head is upside down (and it makes no sense as a painting if looked at right side up) it gives a curious sense of calm abandon (Fig. 3), when turned (painted from the back) a feeling of total rejection. In *The Black Dress* she appears in several attitudes simultaneously, in one of Katz's most "cool" paintings.

Katz is a cool painter. Utilizing some of the effects of the Intimists to reinforce an abstract schema based on figuration and a technique which is "post-painterly," he poses a problem in evaluation for American critics and connoisseurs of the New, an enviable position which one hopes he is able to maintain in a situation where virtually everything else has been gobbled up, if not assimilated or understood.

5 Participants
in a Hearsay Panel

Script conceived and recorded by Elaine de Kooning after three evenings of private discussion by Joan Mitchell, Elaine de Kooning, Frank O'Hara, Mike Goldberg, and Norman Bluhm of the panel, with careful attention to misattribution and misquotation in keeping with the spirit of the art world. (Some of the quotes, however, are accurate.) The script was then tampered with by Frank O'Hara with further alterations by the other members of the panel. Final tampering and typing by Elaine de Kooning.

JOAN: We'll open with a question. Is style hearsay?

FRANK: Well Pavia says, nowadays everyone talks about you behind your behind your back in front of your face.

ELAINE: Yes. Philip Guston told Andrew Wyeth that Louis B. Mayer told John Huston: Well, if you don't like it here, go back to Greenwich Village and starve on a hundred dollars a week.

NORMAN: Frank says: Style at its lowest ebb is method. Style at its highest ebb is personality.

MIKE: Norman is worried because lately he finds himself being polite **149**

to everyone. He meets someone and he says How do you do? I'm very happy to meet you when he's not happy at all.

ELAINE: At openings, Norman says, the greeting of people has nothing to do with the greeting of people. Norman also thinks the Whitney Museum looks like a drugstore.

NORMAN: The fear that someone else is liable to know something around here touches me.

FRANK: Harold Rosenberg says that artists read paintings and look at books.

NORMAN: Would the noisy Black Mountain Boys stop picking the change off the bar. We will buy you your beers anyway.

ELAINE: Betsy says, In matters of art, it's Vanity and Vexation not virtue that triumphs.

MIKE: It has been rumored that rats have eaten the major portion of the paintings at a major uptown gallery.

FRANK: Elaine says Pavia says Dogs don't mind being dogs. The panel has heard—hasn't it, Joan—that certain galleries have dropped all their artists and are looking for promising new talent. Now, if some of you look fast—

JOAN: Norman, you have a letter?

NORMAN: Yes, I do. Open letter to the new, that all the tears of arrival, the problem of eating at Rikers, the tragic element of the pat on the back, the events of the show that will never arrive, the forever nagging wife. . . .

MIKE: Ah, there should never be those civil marriages!

NORMAN: Till death do us part means you'll never get out alive.

FRANK: Lovers always think their glances are invisible.

NORMAN: But if the heart of man can scratch the balls of the earth, brothers raise up your lonely brushes, great paint at the Brata, a new surface, loin cloths at the cave galleries. . . .

ELAINE: Lewitin has a small reducing glass that makes everybody's paintings look like his own. But that doesn't make him *like* everybody's paintings.

NORMAN: To you who are before my eyes, if you think that we are about to speak of art in the tears of space, light, and the elements of line etc. plus factors that have been cried and continue to cry, do you think that we are about to open that which is the feeling of man himself. . . . Then all of the questions would open the eye that is never able to reach from the darkness of the darkness of the dark. Is there any light? (applause)

150

ELAINE: Fairfield says: Why is irrelevancy so often taken for profundity?

JOAN: Pat Passloff thought this panel should be called Artists in Armor.

FRANK: Someone in the know says more women artists keep journals than men do.

JOAN: Now, possibly, the panel will discuss the question of craftsmanship.

NORMAN: It's all crapmanship to me.

FRANK: Elaine says sharpening pencils is practically a lost art.

MIKE: Maureen says she doesn't like to draw in pencil because she doesn't know how to sharpen pencils.

NORMAN: When I was studying architecture with Mies in Chicago, we were taught to sharpen pencils toward ourselves, like this. It took two weeks to find the correct position of the blade.

ELAINE: Toward you is the masculine way. I always sharpen pencils away from myself.

MIKE: That's only natural. Anything that can hurt you, you do away from yourself.

ELAINE: Then men have an advantage.

NORMAN: Only in terms of craftsmanship.

ELAINE: Well, isn't that what we're discussing.

NORMAN: Not any more.

MIKE: Frank says Elaine says Norman is being stuffy again.

ELAINE: I'd like to recite a little poem about Norman I commissioned from Frank:

> *I think Norman's swell,*
> *he doesn't seem to like Mies*
> *anymore but he talks about him*
> *all the time, especially when*
> *he's drawing. I think that's*
> *sweet. It means that things last*
> *and not only buildings. Oh lake! Oh shore!*

NORMAN: Thanks, Frank.

ELAINE: Frank has asked me to announce that none of the sentiments expressed in this poem are his. They're mine.

FRANK: Ernestine Lassaw told Franz Kline and Tom Young that Bob Rauschenburg told her that Joseph Cornell saw a beautiful girl in a box, a cashier's box, outside a movie house and he used to ride past the movie house on his bike every day to look at the girl in the box. Then, one day, Ernestine said Bob said, he—Cornell—picked a little bouquet of blue wild flowers and carried them up and down on his bicycle in front of the movie house before he finally screwed up his courage and thrust the flowers through the hole in the box at the girl. She screamed for the manager who called the police but the police let Cornell go.

151

MIKE: Right now, I notice, there is a worship of the New.

NORMAN: Well, naturally. There's only one thing new to anyone. That's himself. That's why we paint in the first person singular.

MIKE: It doesn't look so singular to me. Why is it that Hot-off-the-griddle art is usually hot off somebody else's griddle?

FRANK: Bob says we're a generation of swipers.

ELAINE: Joan says Norman said: It's third person art parading as first person art.

FRANK: George says Mayakovsky says Third person art involves craftsmanship.

MIKE: All art involves craftsmanship.

ELAINE: Dada didn't.

MIKE: Yes, but Neo-Dada does. As soon as any gesture is repeated, craft is involved.

JOAN: Neo-Dada has become Neo-Mama.

NORMAN: Neo-Mau Mau, you mean.

FRANK: Neo-Meow Meow.

MIKE: Neo-Moo Moo.

ELAINE: Well, according to a noted museum director, the only thing that sells right now is Neo-Me Me.

FRANK: Someone who recently left the country said: Why is it all right to be influenced by a dead artist and a scandal if you're influenced by a live one?

MIKE: Well, it's much more dangerous to kill a live artist than a dead one.

NORMAN: You mean it's much harder to rape a live artist than a dead one.

ELAINE: Frank says nobody looks at dead artists anymore. Living artists have become snobs about being alive.

MIKE: Milton says somebody told him somebody in the New Testament said: There is a path which seemeth right to a man but the ways thereof lead to death.

FRANK: It just proves you can't depend on the Bible for guidance.

JOAN: The panel should buy a Bible and read it under a tree until an apple falls on its head. Then it might discover gravity.

FRANK: Simone de Beauvoir says Sade said: There would be neither gravitation nor movement. . . .

NORMAN: She also says he said: The idea of God is the sole wrong for which I cannot forgive mankind.

ELAINE: Anne Porter's Godmother, Miss Kelly, says: You have to believe in Hell, but you don't have to believe there's anybody in it.

MIKE: I'd like to ask a question. If you rub a nylon stocking against a plaster wall, will the stocking fill with air?

152

ALL: Yes.

MIKE: That's all I wanted to know.

NORMAN: Has the situation changed from what we don't have to do anymore to what we don't have to do again to what we still don't have to do?

MIKE: Everything will be all right if we stay up there with the top 98% of the nation's painters.

FRANK: I agree with Auden about Henry James. Henry James is the only twentieth century artist who . . .

MIKE: I'd like to ask a question: Why is it so many artists after taking one lesson on the piano want to play like Horowitz?

NORMAN: It's like some bourgeois would say that, you know.

ELAINE: Peter Stander said if Giotto had a one-man show tomorrow, he'd be famous. Peter also said: Tradition holds your pants up and the Academy is what you put in your pocket.

JOAN. Perhaps now the panel should discuss the cult of ineptness although Joe LeSouer says it's the sort of thing Lionel Trilling would talk about. You know, the cult of peeling paintings. Mine have cracked but they never peeled. Larry's have blistered. Some artists are said to be envious of Larry because of the Museum fire.

MIKE: I don't think inept painting is bad painting.

NORMAN: NO?

MIKE: Not necessarily. The subject matter of inability comes across. There are some painters who begin a painting lacking lucidity. They start off with a great deal of desire and a lot of stupidity and bludgeon their way through their pictures—and succeed in making forceful honest pictures and then, after awhile, they become masters of their own inability and the honesty of their pictures becomes veiled.

NORMAN. Why talk about artists who want to master their own mistakes. Let's talk about artists who want to master other people's mistakes.

MIKE: That gets us back to craft again—the race to master and surpass the "look" of others. The look is in quotes, you know.

ELAINE: Naturally.

JOAN: That's an Aryan idea.

NORMAN: What idea is that?

JOAN: The master the mass of the super-past. Is there no way of talking about what we're for?

NORMAN: Ortega y Gasset says no. It's a form of exposure. If you feel strongly, you're not sentimental. If you're in love, you don't explain, you itemize. After all, the Song of Solomon reads like a grocery list. For myself, I don't like to talk about what I'm for. I like to talk

153

about what I'm against. I don't like that word Hi. As a matter of fact, that's one word I don't like.

JOAN: What's wrong with Hi. It sounds lighthearted.

NORMAN: Well, I don't like it.

JOAN: Well, I don't like a lot of words you use. Now, let's discuss the stigma of the enigma.

MIKE: Speaking of the time element in art, is it true that today paintings get old faster than songs do?

FRANK: Getting old is not so bad. It's non-existence that hurts.

MIKE: One's real level is the present. Paintings get old when they try to shock. And shock is no longer possible so contemporary Dada becomes wishfully remembered decor—

ELAINE: Allen Oppenheimer would like to know if you're speaking of Herr Dada or Señor Dada or Monsieur Dada.

MIKE: Mister Dada to you.

NORMAN: Why Dada again? You don't want to return to the same thing twice in a row.

MIKE: Say, what kind of love life do *you* have?

FRANK: George says Dada is an art movement that was born in a train wreck and died the same day.

MIKE: About Dada—style becomes inevitably the structure on which one hangs nothing, not even oneself.

NORMAN: Joan says style's not a structure. It's a skin. It's not inside. It's outside.

ELAINE: Fairfield says it *comes* from inside. When asked: Where does it go, Fairfield says—I don't care; anywhere it likes.

MIKE: Style is some thing one builds brick by brick on which one *hangs* the skin.

NORMAN: There's only one reason I don't like that word, skin. It reminds me of architecture.

MIKE: I *want* it to remind you of architecture.

NORMAN: It reminds me of the architect I never became.

JOAN: Why do you want to bring in architecture?

MIKE: I think the individual artist in relation to his art has a structure within himself that he's built up out of all the previous pictures he's ever painted and that, to me, is an architectonic concept.

JOAN: Sounds like a pile of stones to me.

NORMAN: Gall-stones, guile-stones, milestones, stylestones, tombstones. . . .

MIKE: That all goes into marriage.

NORMAN: According to Sarah's husband-in-law, there seem to be quite a few would-be widows (candidates for a dead husband) in the art world but nobody seems to want to marry them, including me.

MIKE: Well, what do you expect of an anxious, single younglady?

NORMAN: What's a glady?

MIKE: You know, a sub-cultural lady with hopes.

NORMAN: Oh, you mean a cultural lion-hunter.

MIKE: There's nobody more refined than a younglady who wants pink minks.

FRANK: Well, I don't know what you're all fussing about. Anyone who chose Goneril and Regan deserved what Lear got. Even a dog would know that. What do you think a great artist is, somebody who buries his dung? No. Somebody in whom it *floats*.

ELAINE: Speaking of dung, I was talking to my mother about architects and their boring designs. . . .

FRANK: Speaking of chair designs, Harold Rosenberg says the only way to criticize a chair is with your bottom.

ELAINE: Well, to go on, my mother said: Isn't it odd—thousands of years and the human race has come up with only five pieces of furniture.

NORMAN: Mr. Wizard says: Look through the lenses of a pair of eyeglasses held at arm's length. If the wearer of the glasses is far-sighted, you will probably see upside down images in his convex lenses. This doesn't happen to be true because we've all tried it but anyhow. . . .

MIKE: Walk into any room and look around. It is certain that there are a couple of lenses around. Where. Right in your eyes!

ELAINE: Michel Sonnabend says: What are eyes? Those holes in front of your brain.

JOAN: Bill said: If you've never loved blindly, you love only God.

ELAINE: Emily Dickinson said: Nature is a haunted house. Art is a house that tries to be haunted.

FRANK: Thoreau said: No matter how I try to think of Nature, my thoughts go constantly to plotting against the State.

MIKE: Elaine's brother, Peter, to whom I'm personally devoted, said: Why live simply when it's so easy to make life complicated.

NORMAN: I've heard that if you like men whose lips move when they read silently to themselves, then you won't like Matthieu.

JOAN: Can you honestly tell me why anyone *should* like Matthieu.

ELAINE: Frank says the Greek heroes were damned lucky to have their tragedies revealed to them. Otherwise they would have spent their

whole lives bored.

FRANK: Marie says: People who bear their troubles are dunces. When asked what people should do about their troubles, she said: Get rid of them.

JOAN: Everyone agrees.

A Short Chronology

1926 Francis Russell O'Hara was born on June 27, in Baltimore, Maryland, the oldest of the three children of Katherine Broderick O'Hara and Russell J. O'Hara (both parents were originally from Worcester, Massachusetts).

1927 The family moved to Grafton, Massachusetts, where they resided at 16 North Street.

1932 – 40 Attended St. Paul's School in Chatham Street, Worcester. Studied piano and, later, harmony with private teachers in Worcester.

1940 – 44 Attended St. John's High School, then located in Temple Street, Worcester.

1941 – 44 Studied piano with Margaret Mason as a special student at the New England Conservatory, Boston.

1944 – 46 Served as sonarman third class on the destroyer USS *Nicholas*. Stationed at Norfolk, Virginia, in California, and sailed in the South Pacific and to Japan.

1946 – 50 At Harvard College he first majored in music, then changed his

157

major to English; B.A. 1950. Here he met John Ashbery, Violet (Bunny) Lang, and George Montgomery; and published poems and stories in the *Harvard Advocate*. He was one of the founders of the Poets' Theatre, Cambridge, and worked with the Brattle Theatre as stage apprentice during the summer of 1950. On visits to New York he met Jane Freilicher, Kenneth Koch, Fairfield Porter, and Larry Rivers.

1950 – 51 Graduate school studies at the University of Michigan, Ann Arbor; M.A. 1951. Received a major Hopwood Award in Creative Writing for "A Byzantine Place," his manuscript of poems, and a verse play *Try! Try!* The judges were Karl Shapiro, Louis Untermeyer, and Peter Viereck. The original versions of *Try! Try!* and *Change Your Bedding* were produced by the Poets' Theatre in 1951, along with John Ashbery's masque *Everyman*, for which he composed the incidental music. He prepared John Latouche's *The Golden Apple* for publication. In the autumn he moved into an apartment at 326 East 49th Street. He worked briefly as private secretary to Cecil Beaton, and was employed on the front desk of the Museum of Modern Art. He met Joseph LeSueur and James Schuyler.

1952 *A City Winter, and Other Poems,* his first book of poems, was published by Tibor de Nagy Gallery. He participated in several panel discussions at The Club of the New York Painters on 8th Street. During this period he met Helen Frankenthaler, Barbara Guest, Grace Hartigan, Joan Mitchell, Edwin Denby, Alfred Leslie, Michael Goldberg, Franz Kline, Elaine and Willem de Kooning, Philip Guston, Jackson Pollock, Ned Rorem, and many other writer, composer, and painter friends.

1953 *Oranges* was issued by Tibor de Nagy on the occasion of the exhibit of Grace Hartigan's *Oranges* paintings. He resigned from the Museum of Modern Art to become an editorial associate of *Art News* (1953–55), to which he contributed regular reviews and occasional articles. The second version of *Try! Try!* was produced by the Artists' Theatre, and he acted in the Living Theater's production of Picasso's *Desire Caught by the Tail* at the Cherry Lane Theatre.

1954 His essay "Nature and New American Painting" was published in *Folder* 3.

1955 – 66 He rejoined The Museum of Modern Art in 1955 as a special assistant in the International Program, working under Porter A. McCray, then its Director. He assisted in the organization of many important traveling exhibitions, including administrative responsibilities for *De David à Toulouse-Lautrec: Chefs-d'Oeuvres des Collections Américaines (From David to Toulouse-Lautrec: Masterpieces from American Collections)* shown in Paris 1955; *The New American Painting,* the first exhibition of American Abstract-Expressionism circulated in

Europe 1958–59 (directed by Dorothy C. Miller); and *Twentieth Century Italian Art from American Collections,* shown in Milan and Rome, 1960 (directed by James Thrall Soby). He worked closely with Renée Sabatello Neu and Waldo Rasmussen.

He assumed independent directorship of many exhibitions, the majority of which were organized for circulation, either in the United States or abroad. In 1960 he was appointed Assistant Curator of Painting and Sculpture Exhibitions, in 1965 Associate Curator, and in 1966 Curator. He selected U.S. representations for the following international exhibitions: IV International Art Exhibition, Japan, 1957; IV Bienal, São Paulo, Brazil, 1957 (sections comprising a group exhibition of five painters and three sculptors and *Jackson Pollock: 1912–56,* a memorial exhibition which later traveled in Europe, 1958–59); XXIX Venice Biennale, 1958 (Seymour Lipton and Mark Tobey sections); with Porter A. McCray, *Documenta II '59,* Kassel, Germany, 1959; and VI Bienal, 1961, São Paulo, Brasil (Robert Motherwell and Reuben Nakian sections). The following exhibitions were shown at The Museum of Modern Art, New York: *New Spanish Painting and Sculpture,* 1960 (afterwards circulated in the U.S.); *Robert Motherwell,* 1965 (afterwards shown in Europe); and *Reuben Nakian,* 1966. Other exhibitions under his direction which were circulated widely after 1961 include: *Sculptures by David Smith* (U.S., 1961–63); *Magritte-Tanguy* (U.S., 1961–62); *Abstract Watercolors by 14 Americans* (U.S., Europe, Asia, Australia, and New Zealand, 1962–66); *Gaston Lachaise* (U.S., 1962–64); *Drawings by Arshile Gorky* (U.S., Japan, Europe, and South America, 1962–67); *Drawings by David Smith* (U.S., 1963–66); *Franz Kline* (Europe, 1963–64); *Recent Landscapes by 8 Americans* (U.S. and Spoleto, Italy, 1964–66); *Robert Motherwell: Works on Paper* (U.S. and Latin America, 1965–68); *David Smith* (Europe, 1966–67). With René d'Harnoncourt, Director of the Museum, he codirected *Modern Sculpture: U.S.A.* (Paris, Berlin, and Baden-Baden, 1965–66). At the time of his death he had begun work on a major retrospective of Jackson Pollock, and he had at last secured Willem de Kooning's agreement to organize a large retrospective of his paintings.

Throughout this period he wrote poems or short prose for artists' gallery catalogues, including: Norman Bluhm, Helen Frankenthaler, Jane Freilicher, Mike Goldberg, Grace Hartigan, Franz Kline, Arnaldo Pomodoro, Larry Rivers, and "Little Elegy for Antonio Machado" for the exhibition *Homage to Machado,* directed by John Bernard Myers at the Tibor de Nagy Gallery as a benefit for refugees from the Spanish War.

Artists with whom he collaborated or who chose his poems to include in their work are: Norman Bluhm, Joe Brainard, Helen Franken-

thaler, Jane Freilicher, Michael Goldberg, Grace Hartigan, Jasper Johns, Alfred Leslie, Beverly Pepper, Larry Rivers, Mario Schifano, Arnoldo Pomodoro.

He had friendships and correspondence with other artists, including: John Button, Allan D'Arcangelo, Niki De Saint Phalle, Jean Dubuffet, Al Held, Lee Krasner, Marisol, Joan Mitchell, Barnett Newman, Claes Oldenburg, Jean-Paul Riopelle, Pablo Serrano, Jean Tinguely, Cy Twombly, Matsumi Kanimitsu, Nell Blaine, Al Held. He formed many friendships with people in music, dance, and the theater, among them: Virgil Thompson, Aaron Copland, Morton Feldman, Ben Weber, Arthur Gold, Robert Fizdale, Lincoln Kirstein, Gaby Rogers, Arnold Weinstein, Merce Cunningham, Paul Taylor, Arthur Mitchell, Vincent Warren, and Dan Wagoner.

1956 He accepted a one-semester fellowship at the Poets' Theatre in Cambridge, where he produced and acted in John Ashbery's *The Compromise;* and met John Wieners. Back in New York he collaborated with Arnold Weinstein and John Gruen on the musical comedy *Undercover Lover.* Met Norman Bluhm returned from Europe.

1957 Moved with Joe LeSueur to 90 University Place. *Meditations in an Emergency* published by Grove Press. Met Patsy Southgate, Gregory Corso, Allen Ginsberg, and Jack Kerouac.

1958 *Stones,* the lithographs he made with Larry Rivers, were published by Universal Limited Art Editions. Met Kynaston McShine of the Museum of Modern Art, and Alex Katz. First trip to Europe, when he met many Spanish artists whom he was later to include in *New Spanish Painting and Sculpture* exhibition; visited Berlin, Venice Biennale, Rome, and Paris.

1959 Moved to 441 East 9th Street. "About Zhivago and His Poems" published in *Evergreen Review. Love's Labor, an eclogue* produced by the Living Theater. Met Vincent Warren, the dancer, LeRoi Jones, Bill Berkson, Frank Lima, and many other young poets.

1960 *Odes,* with five serigraphs by Mike Goldberg, published by Tiber Press; *Second Avenue* published by Totem/Corinth Press. *Awake in Spain* produced by the Living Theater, and published in *Hasty Papers. Try! Try!* (in *The Artists' Theatre,* edited by Herbert Machiz) published by Grove Press. In October he painted 26 poem-paintings with Norman Bluhm. Met J. J. Mitchell and Tony Towle. Traveled to Spain to organize the exhibition of Spanish painting and sculpture, and to Paris.

1961 Became art editor of the quarterly *Kulchur* and contributed art chronicles regularly. Traveled to Rome and Paris in October.

1962 Received a grant from the Merrill Foundation and took a brief leave from the museum to write.

| 1963 | | Taught a poetry workshop course during the spring term at the New School for Social Research. Moved to 791 Broadway. Started a collaboration with Jasper Johns on poems/lithographs. In the fall, traveled to Europe for opening of the Kline exhibition at Stedelijk Museum in Amsterdam, and for a second showing at Museo Civico di Torino. Also went to Antwerp, Paris, Milan, Rome, Copenhagen, Stockholm, Vienna, Zagreb, Belgrade, and Prague. He discussed possible future exhibitions with Eastern European museum staff and met many artists. Was in Prague at the time of President John F. Kennedy's assassination. In Amsterdam he visited studios of young Dutch artists and met the artist and novelist Jan Cremer. |

1963 64 Collaborated with Al Leslie on the film *The Last Clean Shirt*, for which he wrote the subtitles.

1964 *Lunch Poems* published by City Lights Books. *Audit/Poetry* published an issue "Featuring Frank O'Hara." *The General Returns from One Place to Another* was produced by Present Stages at the Writer's Stage Theatre; it was published in *Art and Literature* in 1965. Interviewed David Smith and Barnett Newman for the National Educational Television *Art: New York* Series. Al Leslie projected a collaboration, a series of animated films to be based on O'Hara's poems, but only the drawings for POEM (The eager note on my door said "Call me,") were completed. They were published with the poem in *In Memory of My Feelings* (1967, edited by Bill Berkson).

1965 *Love Poems (Tentative Title)* published by Tibor de Nagy. Interviewed by Edward Lucie-Smith for *Studio International*. Helped choose poets invited to Settimano di Poesia, Spoleto Festival of Two Worlds, in the summer. Collaborated with Al Leslie on the film *Philosophy in the Bedroom*, for which he wrote the subtitles. Featured in the National Educational Television *USA: Poetry* Series.

1966 Traveled to Europe in the spring for the Smith exhibition in Otterlo, Netherlands. He collaborated with Joe Brainard on collages and drawings.

In the early morning of July 24 he was struck and gravely injured by a beach-buggy on the beach of Fire Island. Taken to Bayview Hospital in Mastic Beach, L.I., he was given massive transfusions and underwent an exploratory operation, but his condition deteriorated and he died at 8:50 the evening of the 25th. On the 28th he was buried in the Springs cemetery, near East Hampton. Larry Rivers, Bill Berkson, Edwin Denby, and René d'Harnoncourt, Director of the Museum of Modern Art, delivered eulogies; John Ashbery read from his poems; and Allen Ginsberg and Peter Orlovsky chanted sutras over his grave. On his tombstone is carved "Grace to be born & live..."

Selected Bibliography—Writings on Art and Artists by Frank O'Hara

Reviews and Previews, *Art News,* December 1953 through December 1955

"Nature and New Painting," *Folder,* No. 3 1954, 8 pages

"Porter Paints a Picture," *Art News,* January 1955, pp. 38–41, 66–67

"Cavallon Paints a Picture," *Art News,* December 1958, pp. 42–45, 66

"Franz Kline Talking," *Evergreen Review,* 1958, pp. 6–15

Jackson Pollock, George Braziller, 1959, pp. 11–32

"Jackson Pollock 1912–1956," in Peter Selz, ed., *New Images of Man,* Museum
 of Modern Art, 1959, pp. 123 and 128

"5 Participants in a Hearsay Panel," *It Is,* no. 3, winter–spring 1959, pp. 59–62

"Non-American Painting," *It Is,* no. 3, winter–spring 1959, p. 76

"Larry Rivers: The Next to Last Confederate Soldier," in B. H. Friedman, ed.,
 School of New York: Some Younger Artists, Grove Press, 1959, pp. 60–65

"Larry Rivers: 'Why I Paint As I Do.' " *Horizon,* September 1959, pp. 95–102

New Spanish Painting and Sculpture, Museum of Modern Art, 1960, pp. 7–10

"David Smith: The Color of Steel," *Art News,* December 1961, pp. 32–34, 64–
 65

"How to Proceed in the Arts" (with Larry Rivers), *Evergreen Review,* August
 1961, pp. 97–101

"Robert Motherwell," from Catalog of VI Bienal do Museu de Arte Moderna, São Paulo, 1961: Estatod Unidos, 3 pages

"Robert Motherwell," from *Robert Motherwell, A Retrospective Exhibition*, Pasadena Art Museum, Feb. 18 through March 11, 1962, 2 pages

"Philip Guston," *Art News*, May 1962, pp. 31–32, 51–52

"Art Chronicle," *Kulchur*, spring 1962, pp. 80–86

"Art Chronicle," *Kulchur*, summer 1962, pp. 50–56

"Art Chronicle," *Kulchur*, spring 1963, pp. 55–63

"Riopelle: International Speedscapes," *Art News*, April 1963, pp. 33–34, 64–65

"Introducing the Sculpture of George Spaventa," *Art News*, April 1964, pp. 45–47

"Introduction and Interview," from *Franz Kline, a Retrospective Exhibition*, Whitechapel Gallery, London and Museum of Modern Art, 1964. This includes "Franz Kline Talking," *Evergreen Review*, 1958, pp. 6–15

Robert Motherwell, Museum of Modern Art, 1965, pp. 8–10, 15, 18–19, 23–4, 30

"The Grand Manner of Motherwell," *Vogue*, October 1965, pp. 207, 263–65

"Larry Rivers: A Memoir," Poses Institute of Fine Arts, Brandeis University Catalogue, *Larry Rivers*, 1965 (This is included in Donald Allen, ed., *The Collected Poems of Frank O'Hara*, Alfred A. Knopf, 1971)

"Alex Katz," *Art and Literature*, 9, summer 1966, pp. 99–101 (This is included in Bill Berkson, Irving Sandler, eds., *Alex Katz*, Praeger, 1971, pp. 39–42)

Nakian, Museum of Modern Art, 1966

David Smith, Museum of Modern Art, 1966, pp. 7–9, 11, 13, 16, 19

Standing Still and Walking in New York, edited by Donald M. Allen, Grey Fox Press (in press). This includes: "Nature and New Painting," "Porter Paints a Picture," "Franz Kline Talking," the three art chronicles, "Norman Bluhm," "The Grand Manner of Motherwell," "Riopelle: International Speedscapes," . . .)

Selected Poetry Bibliography
1966—1974

In Memory Of My Feelings, edited by Bill Berkson, Museum of Modern Art, 1967

The Collected Poems, edited by Donald M. Allen, Alfred A. Knopf, Inc., 1971

The Selected Poems, edited by Donald M. Allen, Alfred A. Knopf, Inc. and Vintage Press, 1974

Hymns to St. Bridget, by Bill Berkson and Frank O'Hara. Adventures in Poetry, 1974

Poems Retrieved, edited by Donald M. Allen, to be published by Grey Fox Press (in press)